The Art of dreaming

The Art of dreaming

Tools for Creative Dream Work

Jill Mellick, Ph.D.

Foreword by Marion Woodman

CONARI PRESS
Berkeley, California

Portions of this book were previously published under the title
The Natural Artistry of Dreams.

Conari Press books are distributed by Publishers Group West.

ISBN: 1-57324-574-7

Cover Photography: Photonica: Red, Purple and Blue Swirl by
Masaaki Kazama, and Stopwatch, Face by Ann Cutting

Cover and Book Design: Suzanne Albertson

Interior Illustrations: Chapter art openings by Jill Mellick

Chapter figures by Lutzka Zivny

LIBRARY OF CONGRESS CATALOGING-IN-PUBLICATION DATA

Mellick, Jill.
The art of dreaming : tools for creative dream work /
Jill Mellick ; foreword by Marion Woodman.
p. cm.
Includes bibliographical references and index.
ISBN 1-57324-574-7
1. Dreams. 2. Dream interpretation. 3. Jungian psychology. I. Title.
BF175.5.D74 M44 2001
154.6'3—dc21
2001001909

Printed in Canada on recycled paper

01 02 03 04 TR 10 9 8 7 6 5 4 3 2 1

You gave it back,

knowing, as I did not,

it was mine

to hold and grow.

So this one's for you:

to open the heart

is the finest art.

J.

I dreamt another bird and I were flying
in the silence of the night.
The other bird was flying just below me,
accompanying me, supporting me,
both of us sustained by soundless currents of air.

<div align="right">—Dreamer</div>

At birth, it enters into us, that bird....
It dwells in our deepest depths.

<div align="right">—Hamsa Upanishad</div>

In genuine metaphor
the illuminating image arrives from another world,
as a bird through the window of your room,
to quicken the transposition of natural appearances
and their power of significance....

<div align="right">—Jacques Maritain</div>

The Art *of* Dreaming

Foreword
by Marion Woodman

Some people say, "Of course, I honor my dreams, even if I don't know what they are about." Some say, "I never dream," or "I dream, but I can't remember my dreams." Others say, "I dream, but I can't make any sense of my dreams." Still others may say, "I think I understand my dreams, but I know I'm not getting to the heart of them."

Beginners, veterans, therapists, and counselors—anyone who has experienced any of these responses, yet genuinely yearns to explore dreams in their full beauty and intricacy—will surely treasure *The Art of Dreaming*.

The author, Jill Mellick, is a musician, artist, and psychotherapist who honors the unconscious in the poetry of her own life. She has also lived among peoples of cultures not bound by linear thinking. She

recognizes the power of the metaphor in the creative process and the power of the creative process in healing. In this book, she has woven her understanding of music and painting with her understanding of psychotherapy and other cultures. The ideas she offers weave a tapestry that speaks directly to the healing powers of the unconscious as it compensates for the one-sidedness of consciousness. Immediately, it senses new possibilities in *playing* with a metaphor, possibilities that may lead to buried feelings, lost connections, new resonances in the psyche and in the cells of the body.

Jill understands the innate structure of a dream. She also understands how people lock themselves into one specific way of working with a dream and thereby limit the full flowering of the images. Whatever is innate is far too multidimensional to be bound to a one-dimensional, fixed mode of perceiving it. In *The Art of Dreaming,* she finds alternative structures related to dance, music, painting, poetry, and sculpture that can act as a container for the dream. At the same time, they provide ways of working with the images without restricting them to the linear thinking that, until recently, has dominated Western culture.

In any dream, as in any poem, the image is the content and the structure. Perhaps other cultures understand the dream story more easily than do we with our linear minds. Thus, their ways of working with dreams, as Jill sensitively demonstrates, are worthy of our attention. As we experiment with other approaches, we will find new ways of relating to the psychic reality of the metaphor upon which the coherence of the dream depends.

Metaphor is the literal language of the soul. Poets do not try "to think up metaphors." They are not interested in making up riddles for

the rest of us to figure out. They think in metaphors. In his poem, "The Tyger," for example, William Blake poses an immense theological question in one simple line,

Did he who made the Lamb make thee?

Organic images are destroyed if we subject them to linear thinking. How often we judge them as "bizarre" or "weird." They need to be allowed to grow like plants in a spiraling movement. They carry emotional and imaginative energy as well as intellectual meaning, and as they spiral they are illumined with nuances of feeling. Hence their power to bring wholeness. Momentarily, we may suddenly think, feel, and imagine at the same instant. We may experience ourselves as whole, with a moment of "goose flesh" that says, "Yes." We may lose the sense of totality almost at once, but the psyche and body have experienced what wholeness is. They can then reconnect to that still point as to a tuning fork. Where consciousness and the unconscious intersect at the still point, that is where we are whole. That still point, as Jill demonstrates again and again throughout this book, is discovered in bringing to the dream's unconscious process an unobtrusive consciousness that cherishes rather than judges.

This book is a delight. As image transforms into image, we are reminded of Blake's butterfly:

He who binds to himself a joy

Does the wingèd life destroy

But he who kisses the joy as it flies

Lives in eternity's sun rise.

The dream carries within it what Coleridge calls "the sacred power of self-intuition." Those who can recognize in their dreams the unconscious operation of this power are those, Coleridge suggests, "who within themselves can interpret and understand the symbols, that the wings of the air-sylph [butterfly] are forming within the skin of the caterpillar; those only, who feel in their own spirits the same instinct, which impels the chrysalis of the horned fly to leave room in its involucrum for antennae yet to come. They know and feel, that the *potential* works *in* them, even as the *actual* works *on* them!"

In dreams the *actual* that works on us by day becomes the potential that works in us by night. This conversion of the actual into the potential (the waking state into the dream) vastly enlarges our sense of the actual and by doing so vastly enlarges our life. The actual carries through the dream a potential for meaning that without the dream might never be discovered. In this book, Jill Mellick explores, in a wide-ranging series of perspectives, the dream potential in the actual. The result is a sense of the actual as a perpetually expanding universe that is always already situated "in eternity's sun rise."[1]

[1] Samuel Taylor Coleridge, *Biographia Literaria,* Vol. 2, ed. by James Engell and W. Jackson Bate, Bollingen Series LXXV (Princeton, NJ: Princeton University Press, 1983), pp. 241–2.

Entering Your Dream World

> A dream tells you where you are, not what to do;
> or, by placing you where you are, it tells you what
> you are doing.
>
> —James Hillman, *The Dream and the Underworld*

Let me invite you to enter into your dream world in new ways, both innovative and traditional, and to enrich your psychospiritual development through expressive dream work.

If you have experience in working with dreams, I invite you to dip into this chapter to revisit and make more conscious your assumptions about dreaming, dream theory, and dream work. I also invite you to entertain holding paradoxical views and contradictory theories about how dreams operate—in time, in space, cross-culturally, and across media.

If you are new to dream work, I invite you to walk with me in this new realm with curiosity and openness to many theories and approaches, any one of which might become relevant and helpful to you at a particular moment or for a particular dream.

Most important, I invite you to join me in deepening your dream experiences by expressing them through a wide variety of creative arts, both verbal and nonverbal, including visual art, movement, poetry, myth, fairy tale, dramatization, wordplay, imaginative journeys, art media, and ritual.

Dreams prove that in our inner world we are effortless and talented creative artists—superb wordsmiths, mythmakers, fine artists, and craftspeople capable of simile, metaphor, symbol, and imagery unbounded by the cognitive restrictions of waking life. By using simple multimedia arts practices, we can let our dreams express their artistry in our waking world as well as in our dreaming world.

Some practices in this book assume the value of symbolic interpretation. Others provide ways to bring understandings from dreams into daily life. Others offer ways to nurture imagination. Still others focus on narrative threads that weave dream fabric. Many break out of linear storyline (especially conventional Western storyline), inviting you to experience your dream as a nonlinear artform such as haiku, collage, claywork, or body experience. If you suspend disbelief and embrace each new approach as a possible lens, you can discover those practices that most enhance both your dreaming and waking lives.

Receive Dreams as Messengers from Another Realm

Dreams haunt us with their images, words, sounds, and feelings. They often influence our inner and outer lives. They disturb, amuse, intrigue, haunt, and inspire. They are messengers from another realm, with their own logic that is antithetical to daylight logic.

Dreams use the narrative structure of the soul, a logic that dispenses with cause and effect, that exists in a timeless, spatially unbounded universe where we are allowed to do the impossible: to occupy two timeframes or places at once; to be our current age but in our childhood home; to change our sex; to be older and younger; to experience the consciousness of two people at once; to see events from different perspectives simultaneously; to be in the present as well as the future; to be both dead and alive. Wiser and more humorous than we, dreams remind us that we are subject to larger forces and influences than we tend to acknowledge on a daily basis. Many of our most profound images surface from dreams.

What happens if we let our dream world constructively intersect with our waking life? What if we pay creative attention to our dreams, consciously allowing their imagery, patterns, and forms into our waking consciousness? The wisdom of the dream can balance or affirm our waking attitudes. The heart of the dream can beat in our actions and in the presence we bring to situations.

We do not always need to "understand" or interpret dreams to receive their gifts to heart and soul. Rather, we can circumambulate them, respect them, let their images feed our imaginations and lead us onward, just as a glimpse of ocean or lake renews and orients and refreshes us on a long drive. Fine plays and films leave images hovering in awareness—the hand reaching out across the car seat, the old letter being opened, the long shadow across the lawn. They also engender feelings that linger in the heart—inspiration, paradoxical whimsy, poignancy. Even a film in an unfamiliar language can still touch something universal in the depths of the heart.

Treat Your Dream World as a New Culture

My approach to dreams has its roots in curiosity, since childhood, about my own dreams. The wisdom of Carl Jung, Jungian theorists, and other selected theorists have watered and fertilized those roots and shaped my understanding. So has a lifelong interest in and involvement with other cultures' worldviews.

My first undergraduate anthropology class was held in a dreary basement auditorium in a formal sandstone building bordering the quadrangle. February marked the humid height of summer in Australia. High, small windows at grass level framed the sky. As I listened to the lecturer talk about how we could study different cultures, something irrevocable happened: my spirit soared out of my uncomfortable body, escaped through those high windows into the cloudless sky, and hovered over the map.

Even though I had been raised with an active appreciation for other cultures, at that moment I saw with silent shock that I still had a culture-bound, ethnocentric worldview. I began to understand that I could look *at* my own culture as well as look out from it. I felt freedom and rumbling anxiety: never again could I put cultural blinkers on and trot unthinkingly through my environment. I did not forget that moment; at the first opportunity, between undergraduate and graduate studies in English literature, I traveled to Papua and New Guinea, where I spent time with the Atzera and Foré tribes.

When my spirit escaped through those windows that blistering summer day and flew around, peering down at my own and other countries, I did not know the experience would eventually inform the way I would look at dreams. Years later, I came to realize that dreams, too, are a different culture, and that even the ways we treat and tell our

dreams are culturally determined. I do not believe that we can use one culture's norms and belief structures to view another's without clouding the cultural integrity of each. The context in which we live, in which we dream, in which we tell our stories, is central to our inner and outer worldviews. And the structures of our lives, dreams, and stories are inseparable from their content.

This approach runs contrary to the beliefs of certain psychoanalytic theorists who analyze dreams from third world cultures, assuming that the narrative structure and content of the Oedipus myth, for example, is a universal template for any culture's psyche and dreams. It also runs contrary to contemporary groups who lift spiritual rituals from one culture and re-enact them within their own, divorcing them from the unique cultural context that engendered these rituals.

I do believe that we can stand back from our own culture and be receptive to others. We can better understand how we construct our templates for realities, both inner and outer. We can also add new awarenesses from other cultures' perceptions, cultures more sensitized to certain experiences than our own.

My personal heritage includes several cultures, and, having grown up in Australia and lived most of my adult life in California, I consider myself bicultural. I have also been fortunate to be able to travel widely and to work in other cultures, including years with the Pueblo Indian communities of the southwestern United States. However, no matter how many ceremonials I attend in the pueblos, I shall always be only a welcomed visitor, never a participant. Nor shall I have more than a superficial understanding of the dance's religious context, no matter how many books I read or feeling I have for the ritual. Nevertheless, I can better appreciate the role of ritual drama, the spiritual impact of

slow, repetitive dance and low singing, and the appearance in religious ceremonial costumes of nature symbols—rain, cloud, mountain. I can breathe in the experience and feel it enrich the breath of my own culture. I can include ritual, dance, art, nature, symbol, and song with more care, intent, depth, and fidelity in my life.

Our dreams, too, enact themselves in a different culture, which we can only ever partially understand. So we must be wary of the preconceptions we bring to our dream culture from our daytime culture or from other cultures. By learning from other cultures' ways of structuring and receiving stories, dreams, images, and experiences, we can enrich our perceptions of and responses to dreams. Free of the constraints of our answer-addicted, deterministic culture, we can open to new secrets, new themes, new ways of listening and attending.

Almost all cultures, across seas and time, have regarded dreams as guides for unmapped spiritual, emotional, and physical—even cultural—territories. There is, too, wide cross-cultural agreement that "big" dreams carry special significance for the individual and even for the whole community. For example, in the Senoi tribe of Malaysia, individual dreams are important to the whole group; in classical Greece, visitors to the healing center at Epidaurus slept in a dream chamber until they had a special dream that opened the way to healing; in certain shamanic tribes, those desiring a big dream or an encounter with their guardian spirit set themselves aside to fast until a dream guide appears.

> For Philippine Negritos, the dream constitutes an equal partner with wakefulness in dealing with reality.
>
> —Carl W. O'Nell, *Dreams, Culture, and the Individual*

Freud considered dreams the "royal road" to the unconscious, to inner worlds of personal history, trauma, and primitive need. Jung believed that dreams draw from not only a personal well of experi-

ence but also from a vast reservoir of universal human experiences, responses, images, metaphors, symbols, and mythology. Jung observed, from deep work with his analysands and himself, that dreams perform restorative, corrective, compensatory, prophetic, and developmental roles in our psyche; that to attend to our dreams is to attend to the cry of the soul. While putting forward the most comprehensive, culture-sensitive, and open system of dream theory to date, Jung also believed it is wiser and more fruitful to approach individual dreams with humility and unknowing because dreams speak on many levels at once, just as a piece of art does.

Familiarity with Freud, Jung, or any other respected dream theorist whose work is consonant with your personal acculturation is helpful but not crucial for fruitful dream work. In fact, interpreting dreams by exclusive and unquestioning application of a template from one theoretical system can be dangerously misleading at times. The theory must take into account the culture, the individual, and *the nature of the individual dream with which we are working.* To apply a theory blindly is to make assumptions about the dream culture without traveling with an open mind. We become souvenir hunters, missing engagement with the vibrancy and mystery of the unknown culture, bent only on collecting and carrying a heavy suitcase of artifacts that will fit into our predetermined decor.

> [We] should in every case be ready to construct an entire new theory of dreams.
>
> —C. G. Jung, *Collected Works*

Work Creatively with Contradictory Dream Theories

The more I read dream theory, the more convinced I am that opting for a single approach deprives us of the richness of diverse perspectives.

Those who impose universal truths ignore cross-cultural diversity. Those interested solely in cross-cultural differences miss archetypal or universal patterns. Those who believe the dream is basically verbal dismiss the observation that dreams use synaesthesia (the mixing of the senses) or originate in the visual area of the brain. Those who focus on narrative and content can forget that the way we tell stories in our culture is just that: the way we tell stories in *our* culture. Dream theorists also take oppositional positions, of which the following are a few:

- Dreams don't exist.
- Dreams are meaningless productions of the brain.
- Dreams mean the opposite of what they say.
- Dreams are all about the past.
- Dreams are all about the future.
- All dreams are ordinary.
- All dreams are sacred.
- Most dreams are ordinary and some are sacred.
- Dreams are only about and for the dreamer.
- Dreams are only products of and produced for the community.
- Dreams preserve the culture.
- Dreams create the culture.
- Dream images use clear symbols that we can interpret.
- Dreams images are not symbolic but purely imagistic.
- We must know the personality and history of the dreamer before we can understand the dream.

- We only need to understand the symbols to understand the dream.
- Dreamers' concerns can be interpreted the same way across cultures because the underlying psychological dynamics are the same.
- We need to know about the dreamer, the culture, and universally generated symbology to fully understand a dream.
- We understand the dream when it just "clicks" inside.
- Feeling a dream "click" is suspicious; sometimes we just make it fit what we want to believe.
- Dreams should always be grounded in daily reality.
- Dreams are their own world and should never be co-opted to serve daily life.
- Dreamer's concerns can only be interpreted within their cultural context.
- All dreams have the same underlying structure.
- Each dream creates its own structure.
- Dreams are primarily verbal.
- Dreams are primarily visual.

In view of this wide and well-argued dissension in dream theory, entertaining many possibilities but taking none as absolute truth seems wiser. There is a time for understanding the implications of dreams for waking life, for making travel to dream country purposeful; we come to learn, to interpret, to understand the symbols, to learn the language, to understand the customs. But there is also a time when traveling to a

> "I think these [dream dictionary] books are very, very bad. They get you off the track because they give a static interpretation.... You have to return to the dream and ask, 'What does it mean to the dreamer?' and that is always much more specific."
>
> —Marie-Louise von Franz, in Fraser Boa, *The Way of the Dream*

country is an end in itself, when we can let the journey nourish and sustain us without our needing the experience to change our lives.

Not all books on dreams are rooted in experience and wisdom. Many simplified and illustrated guides to dreams and their symbols have the sensitivity of an elephant on ice skates and the reliability of politicians' economic predictions. The Jungian theory of archetypes and other symbolic theories are easily mimicked but rarely accorded the subtlety or spirit of inquiry they deserve. It is easy to seduce with gross generalities. It is even easier to be seduced by them. They give certainty where there is none. Be wary of books that offer easy and authoritative solutions, particularly to approaching dreams. Jung believed that we must be ready at any moment to construct an entirely new theory of dreams. He maintained a spirit of inquiry and eternal curiosity about his research. For him—and for us—the dream itself is the final authority on itself, and we are forever the students.

Find Your Dream's Organic Art Form

Most theorists assume a dream's narrative structure exists almost independently of its substance, like a frame waiting for a painting, or a survey for answers. Many even believe that if the dream (as it is reported in *words*) lacks a defined beginning, middle, and end, something is awry or unformed in the dream or dreamer.

We have a dream experience. Then we reconstruct the dream in memory. Still later, we use words to represent the memory of the dream.

The actual dream gets further and further away. Language reduces dreams from several dimensions to just two, and customarily reduces perception to linear descriptions of past, present, and future.

So often, we treat the words as though they *are* the dream. Sometimes, they are, indeed, vitally connected to the life force of the dream. More often, they are a pale and flat record of a rich and timeless experience. We are accustomed to using this one artistic medium (words) in one particular form (story) to express dreams. However, there are other, more flexible ways to "re-member" and express them than conventional storytelling. We can express dreams *in the art form that best suits them, in the art form whose structure is most akin to their innate structure.*

When we can loosen our attachment to the linear structure of the sentence by exploring poetry, painting, movement, sculpting, and cross-cultural arts, we open ourselves to new ways of nourishing and being nourished by our dreams.

In *Woman Native Other,* Trinh Minh-ha points out that stories from different cultures are structured in different ways. Each story creates its own structure. She adds that it is not only self-limiting but also oppressive to force Western "beginning-middle-end," cause-and-effect story structure onto another culture and then to evaluate the narrative or retell it in that mode.

We often oppress dreams in the same way; we separate their content and structure. In order to retell our dreams with some verbal, linear coherence, we unthinkingly use Western story structure to make the dream comprehensible to waking consciousness. Unconsciously influenced by telling stories that have a beginning, middle, and end, that wrap up loose ends from certain events or characters, that make one thing lead to the next, we make our dream tales conform to our

storytelling habits, to our need to place them within a familiar narrative framework.

We can miss the point by prestructuring or restructuring experience. Who said that all dreams are stories? And according to whose definition? Many dreams are indeed stories—and our habits of storytelling possibly influence the formation of our dreams. Yet many dreams are not stories but plays, paintings, or poems. Would we "analyze" a poem as a novel? Why, then, do we do this with our dreams?

If we can allow the dream to be what it is rather than comparing it to what it is not, we can allow the dream its own structural integrity, which is probably best expressed through an art form more fluid than conventional story. We need to let dreams paint themselves, dance themselves, sculpt themselves, begin at the end and end at the beginning, spiral in on themselves, meander without climax or major turning point. Perhaps, then, when we can treat content and structure as indivisible, we can truly begin to appreciate the elegant sagacity of the dream.

To Interpret or Not to Interpret: Tradition and Innovation

I refrain from discussing dream interpretation. Rather, I only offer ways to ask questions. I don't know answers and I can't (and shouldn't) give you any about your dreams. Trust your lived experience of what is fitting, creative, and ethical for you. We all choose *a* way but it is unlikely that it is *the* way. It may be *the* way for us, but when we begin to think ours is the only way, we blind ourselves.

Western culture has difficulty holding contradictory beliefs about

the world. Other cultures easily hold paradoxical worldviews. This book provides you with many lenses through which to view your dreams. Many dream theorists and practitioners work with dreams with the traditional techniques noted (following) on the left; others, in the innovative ways noted on the right. This book focuses on innovative activities and attitudes, and also draws on the rich offerings of traditional approaches.

Traditional (Doing)	Innovative (Being)
Analyze	Nourish
Interpret	Explore
Identify	Imagine
Hypothesize	Guess
Work on	Be with, play with
Get a handle on	Fly with
Apply to life	Give life to
Theorize	Inquire
Break down	Connect
Defuse	Infuse
Think about	Create around
Figure out	Sustain the mystery of
Assimilate	Accommodate
Categorize	Allow to evolve
Understand	Appreciate

Traditional (Doing)	Innovative (Being)
Study	Learn
Observe	Participate
Research	Experience
Translate	Learn the language
Decode	Delight in
Tell, write down	Paint, dance, mime, sing, sculpt ...
Denote, connote	Imagine, amplify
Simplify	Enrich

There is nothing inherently right or wrong about any of these approaches. Personality, training, beliefs, and cognitive style determine which selection we make at different times.

How do you work with the material in this book, then, if different ways of exploring your dreams are paradoxical? Practice holding this paradox, without resolving it; practice seeing several "oppositional" approaches as each of worth. Exercise Samuel Taylor Coleridge's "willing suspension of disbelief." Entertain one idea as if it were the only approach that had worth and work with that perspective for a while. Then choose another.

> The difference between a coherent theory and a consistent attitude [to dream work] is that the latter is both more modest in its ambition and more daring in its practice.
>
> —James Hillman,
> *The Dream and the Underworld*

Experiment with a Range of Approaches

Trust your own experience. Experiment with as many ideas in this book as possible. Determine which are helpful to you now. After a few

months, return to ideas you have set aside. What works now might not be what works later. For example, you might find painting a helpful mode for several weeks but one day it loses its potency. Don't force a painting; experiment with poetry or sculpture or some modality that previously did not attract you. Be wary of locking into one approach or belief to the exclusion of others. Choose a frame for viewing your dreams, always remembering that the frame is not the view.

Embrace approaches (and their theoretical assumptions) that bring richness, meaning, and growth to you. Not everyone is suited to deep, extensive Jungian symbolic work or to active, dramatic Gestalt work. Ensure that the approaches you choose do not run counter to your inner direction. For example, acting out a figure in a dream might feel too confrontive at a time when you are feeling stressed. Perhaps you need to draw the figure or write a poem to lower your stress. If an approach runs upstream from your inner movement, it does not indicate that the approach is bad. It simply means that, at this time, this particular approach is too far removed from your worldview for you to derive benefit that would not be clouded by discomfort. You would not be able to integrate it constructively into your life. In the same way, offer possibilities to others based on your own experience, but withhold directives about theirs. Because a way works well for you does not mean that it will work well for your partner, child, parent, therapy client, or friend.

Integrate your time with and understandings from your dreams into your own life. Remember, though, that dreams have eternal worldviews, cultural norms, and customs; you cannot make your life conform to your dreams but you can weave the threads of your understandings from your dreams into the fabric of your life. You can acknowledge the

sense of hurry that was in your dream, for example, and slow down a little in daily life.

If you are in therapy, talk with your therapist about the approaches to your dreams that you are exploring. Some will fit better with your work together than others. Few therapists work equally well with all approaches to dreams. Some will suit your therapist better; others will suit you better. As well as pursuing those approaches that work for you, look for others that provide a common ground of experience. If you have been going through a stressful time, talk with your therapist about the approaches that might be most helpful and least stressful. It is easy to unearth new material within us but harder to integrate it into heart, mind, and life. If you are symbolically inclined, for example, loading yourself down with more symbolism, imagery, and inner work might be just what you *don't* need during a stressful time. You might need to read a detective story or go to a light movie. Be patient. The time for more symbolic work will return.

The dream is more often the companion of the soul than the lackey for daily life. Use pragmatic discernment about the "advice" from dreams. While you can be responsible about and responsive to ideas you suspect your dreams are reflecting to you about your waking life, be wary of *always* co-opting the dream into the service of your daily life and thought.

We would not embark on an African safari without an experienced guide, plenty of provisions, a way of protecting and defending ourselves, familiarity with the risks and environment, ways home, people to call if the going gets rough, and good places to wait out a stampede or storm. The same respectful entry into the dream world is imperative. Do not dismiss its strength; do not go lightly; do not go literally;

and know how to find your way home. Too much time spent in the dream world leaves you disconnected in your daily world, wandering

> The dream is its own interpretation.
>
> —*The Talmud*

around in imagination without a ticket home and unresponsive to dealing with the basic necessities and mutable, tangible demands of daily life. Take the journey dead seriously, but do not take yourself too seriously. Worlds other than the safari need you just as much. Keep balance and visit civilization a lot.

Most of all, distrust fixed interpretations. As Harry Wilmer, Jungian analyst and author, points out, any bag of tricks is suspect. Preface your interpretations with: *This is a way I currently understand this dream.* Otherwise, you risk turning your dream into a robot guru that dispenses unquestioning wisdom. Closed-ended interpretation of subjective phenomena is risky. Listen with open ear and eye to the intimations of heart and soul.

Keep Faith with Your Dream Life

Dream images are sketched in fugitive ink. If we don't re-experience them immediately, they fade to invisibility on the fast-turning pages of waking consciousness.

In the ocean of the unconscious, dreams are swells that rise and pause and break on the shores of personal consciousness, only to suck back, leaving precious flotsam and jetsam on the beach of waking awareness. We cannot influence the tides or the currents, but we can ride the crest of the wave into shore and gather the treasures to us as we walk at dawn.

We cannot make a contract with our dreams. And dreams do not

make contracts with us. Dreams ask trustworthy questions, questions from our deepest selves, perhaps deeper. Dreams promise nothing. They don't give answers. They don't even promise us their remembered presence.

We can, however, make a covenant with our dreams. We can choose to have a passing acquaintance or a deep, long friendship with their questions. We can promise them we shall be with them, record them, sing them, dance them, laugh with and weep for them, draw them. If we are willing to make this covenant, we can then receive what comes from our dreams as unbidden gifts. Two separate, trusting people in a loving, conscious relationship cannot demand reciprocity. They can only offer each other the possibility of being together in ways that allow their best selves to fly into an unknown, often moonless sky sustained by quiet air currents of acceptance.

Like lovers, all we can do is to promise to be there for our dreams—with heart, soul, intellect, body, and discernment. If we can let go of demanding, we can begin to learn the dream's language of love.

The Greek word *psyche* means "butterfly." It is also denotes "soul." Dreams give your soul wings. And images from dreams are the exquisite patterns on the wings. Hold your dream as you would hold a butterfly—in your open, quiet palms. Make sure none of the delicate wing dust brushes off onto clumsy hands. Pinning the dream down with interpretation will tear the wings off the butterfly and kill it. We can put the dead butterfly under glass, study it, admire its uniqueness, and also let others admire it (if they like butterflies). But it will never, never, never fly again.

Hold your dream images gently enough so that they still can fly.

2

Merging Dream Work and
the Expressive Arts

> Poetry and the arts come from the same source and illuminate the same interface as do dreams. Both derive from the formative power of the archetypes which manifest to some extent in time/space and psyche in the form of images.
>
> —Sylvia Brinton Perera, "Dream Design"

Y ou might not consider yourself to be a highly "talented" artist. So perhaps my earlier invitation to explore your dreams through a wide variety of creative art practices is a little daunting. If you are not a professional artist, how do you begin? What is your intention for yourself, for your dream, for your "artwork"? How can you set up an inner and an outer context that is helpful in doing this work?

Let's take a few minutes to explore how to free yourself from your old assumptions and constraints about your creative capacities in the arts, how to prepare your inner life and outer life for deepening your psychospiritual development through simple expressive arts, and how to respect the creative pieces you make.

Exercise Your Birthright to Unique Self-Expression

All cultures value imagination and the arts. When we explore our dreams through simple expressive arts, we also strengthen our innate capacity to creatively express our inner worlds, and we widen the path to our souls.

The food of and for the soul is our imagination. When we do not feed the soul, we die a little. Denying ourselves the fertile inner realm of visual, auditory, and kinesthetic imagery disconnects us from our deepest, most sensitive, and most solid sense of who we truly are. Image, metaphor, symbol, and myth carry and translate messages between outer and inner worlds and among the different domains of our inner world—personal, cultural, and archetypal. The arts express, evoke, and mirror these inner images. By creating and contemplating simple art pieces, we can focus the energies of our own individual and collective experiences.

Rina Swentzell, an architect and Native American, explains that there is no word for art in her language because Tewa people don't experience art as an activity separate from any other. The word that most closely approximates "art" is *po-wa-ha*—"water-wind-breath," the creative force that moves through everything. For the Tewa, creativity is closer than breathing; it is the spirit of life moving endlessly through its cycle. Larger than you or I; po-wa-ha takes us back to the inexhaustible source of life itself and connects us directly to the creative energy. For the Tewa, art is a process, not a product. There is a product, of course. However, to the traditional Tewa potter, the product is incidental; the experience is what is essential and always available. The real product is inner renewal, a sense of oneness with the life force.

Respect the Four Phases of Expressive Dream Work

While your pure creativity is an expression of your soul without conscious interference from your ego-bound goals, if you are committed to your psychospiritual development through expressive dream work, knowing when and how to move from conscious intent to unconscious freedom and back again is crucial.

> Every person is a special kind of artist....
>
> —Rina Swentzell, "The Butterfly Effect"

Expressive dream work evolves through four phases:

1. An intentional departure from ordinary awareness,

2. An inner journey into the imagination,

3. A return to ordinary awareness, and

4. A reflection on the journey.

The artist who paints extraordinary material in a drugged stupor may indeed be creative. However, this artist's creativity is operating in a psychological vacuum and has not been welcomed into the body or into consciousness. Overidentifying with or staying either in strategic artistry or complete unconsciousness during creative sessions diminishes the creator's ability to harness these experiences and learn from them. Such an artist becomes a prisoner in the strange realm of the gods instead of a free traveler.

What distinguishes integrated creativity from this drugged artist's experience are the first and last phases. If you are committed to expressive dream work, set aside a time and a place. Create a protected and private context. Release yourself temporarily from normal awareness,

from personality boundaries. Do this with respect for the power of the dream and other imaginal material that might arise. With intent and context set, undertake your creative work with your dream. Allow material from deep within to surface; commune with the symbol or image. Your whole person and your creative tools become a vehicle for the symbol or image to move from unconsciousness to consciousness, just as they do for all creators, both professional and lay. When you are ready to leave the inner realm, allow time for the experience to come to a close and re-enter "normal" awareness. This conscious completion and departure creates the distance from the experience you need for later reflection, insight, and integration.

Make Time

Neither the soul nor the dream responds in proportion to the linear time you spend on it; there is no inherent virtue in allocating endless periods to your creative dream work. "More time" does not affect quantity or outcome but does affect the quality of the experience: more nourishment for the dream, for the image, for the soul; a more relaxed, contemplative approach; the probability of deeper integration. You are accountable to yourself alone for the time you spend on your dream work. Allocate what time you have and bring full attention, even if it is for five minutes.

Make Space

Dora Kalff, Jungian analyst and developer of sand play therapy, described the optimal environment in which unconscious images can

emerge, pattern themselves, and transform as "a clear and sheltered space." Creative dream work needs right time, right place, and right state of consciousness.

Given your already full life, can you provide these? It is challenging but possible. Our unconscious usually doesn't need much to open up; it has learned to settle for less than optimal circumstances, even if you haven't!

Choose a physical space that is as private as possible—a garage space, the family room, or a bedroom that you can make your own. For example, Alan lived in a small apartment with his wife and young son. He tried working in a small space in the living room. At the end of his first session, his son walked by and said disparagingly: "Dad, your hands aren't even dirty!" His son was right. Alan had set up this place with provisos: he couldn't permit himself or the surroundings to get grubby. He was asking his uncensored creativity to emerge in heavily censored conditions. The next evening, at his son's suggestion, he spread plastic over the floor of his son's bedroom and halfway up the walls, and, together, they made a mess! If, like Alan, you don't have a permanent space, buy yourself large, cheap trays and plastic to cover a floor area. In minutes, you can bring the trays out of storage, lay down plastic, and create work space.

Now that you have space, if possible, don't answer the phone! The more quiet you have, the better you can unfetter your imagination. Consider listening to music. If you live in a small space or with others, use or borrow a small tape/CD player with earphones. Choose contemplative music. I once took my Walkman to a figure drawing class. I delighted in how my body's response to music changed the way I drew.

When you set up your space, plan on using more than one

medium per session. Leave easily accessible paper and pencils for writing, a tape recorder, paper, paints, or crayons, clay, and old magazines and glue for collage.

Let Go of Goals and Judgments

When you consciously decide to explore your dreams creatively, set no goals for the journey. Let go of the need for exact outcomes, particularly those involving excellence, performance, or specific content. Your mind will give overt reasons and directions for what you are doing, but your soul has deeper reasons and directions. If you stay attached to the ostensible, you'll miss the real.

That momentary, magic alignment of will and grace, of conscious intent and unconscious energy, requires detachment from goal. I once attended a figure drawing class led by an instructor who talked incessantly. He would start talking to me just as I was beginning to sketch. Frustrated, I would stop and listen. One evening, I felt so resigned to my distractibility that I let go of my wish to draw well and doodled while he talked. Suddenly, he stopped his solipsistic flow and exclaimed, "Look!" It was the best piece I'd done. I had finally let go of the goal of making a good sketch and surrendered to the process.

In this kind of personal artwork, jettison any idea that you can help yourself or others by interpreting, praising, or criticizing. These kinds of creative pieces and experiences are only for being with. The only helpful response is to nourish the imagination and your piece by associating other images to it and noticing what feelings it evokes in you. Leave your creative piece and its maker richer for exposure to your consciousness, not poorer. Constructive interpretation can often give you a

momentary sense of satisfaction. However, the long-term results of interpretation are less satisfactory; interpretation too often preserves the piece in intellectual formaldehyde when it could have led a long and vibrant life.

Even positive comments (your own or others') contaminate this kind of creative experience. Why not praise? Because one end of the praise continuum evokes the other. When we receive praise or criticism for a personal expression that was never meant to be a performance, we unconsciously use self-deprecation to try to restore a state of equilibrium where we are neither too impressed nor depressed by our performance. And, in trying to rebalance, we forget that we should not be evaluating at all.

I often encourage people not to prepare what they want to talk about during therapy. When they can accommodate spontaneity, they sometimes begin with a dream or image and might use a metaphor to describe their feeling state. Usually, the image reappears elsewhere in the session, often without their being aware. The unplanned, repeated image is a gift from the unconscious, and there is usually a moment when it is ready to reveal itself to consciousness. Just as the prepared session leaves little room for discovery, so does overplanned creative work, especially with dreams. Discovering a repeated image, metaphor, or symbol is usually satisfying and energizing, no matter how shocking! We see how our unconscious has more insight, more coherence than we thought. Observe these recurring images, ideas, colors, shapes, and textures without judgment.

The soul makes itself known to you through your unique mythology and calligraphy. Images nourish you and your journey. They are wellsprings of wisdom when contemplated. However, their efficacy and

> The element of play puts us in our true selves. Play takes us back to how we can be.
>
> —June Matthews,
> C. G. Jung Institute Talk

longevity lie in preserving some of their mystery. Take away all their mystery and you take away their power and life. Experience. Do not evaluate.

Dreams, creative expression, and soul are inseparable. They operate in an endless cycle. Each plays a crucial role in your inner life. Each needs, nourishes, and leads into the other. Treat each with the quiet, curious, and loving respect it deserves.

Free Your Body and Spirit for Dream Work

- *Play first, work later!* Making dream work the reward for having done everything else leads to instant defeat. Where possible, do it early. Feed your soul first; you will do less replenishing things with more grace, heart, and presence.

- *Warm up!* The arts use the whole body; your hands are just the final extension of a whole body response. As you begin, stretch arms, legs, torso, neck, fingers, and facial muscles. Move to music. The music might take you to the ocean, onto a cloud, into the jungle. Welcome these images. Words or sounds might come and go. Watch them. Don't hold on to them. They are bright-eyed, darting fish in the fast-flowing stream of consciousness.

- *Use unfamiliar media and more than one at once.* Arnold Mindell reminds us that the more sense channels through which we absorb an experience, the more chance it has of being integrated into consciousness and the more deeply we are able to resonate with it. Verbal description helps to move insights into waking consciousness, but not all insights are verbal. We do not need a cognitive, coherent, verbal presentation of dream wisdom for it

to work its healing. So moving from one medium to another is crucial to free-flowing creative dream work. For example, by translating the image and feeling of the dream into a body sensation and then transferring this into an abstracted visual form with color and gesture, the gestalt of the dream transforms through different sense channels, giving us several opportunities to nonverbally absorb the experience.

- *Choose media in which you are* not *competent.* When you use a familiar medium, you risk confining yourself to old habits and becoming self-critical. Each medium is a fine teacher, with subtle lessons for certain times. Watercolors teach about letting go, about the uniqueness and evanescence of the moment. Acrylics and oils teach about being able to change direction midstream without apology. Pastels are forgiving, allowing rework and change of intuitive direction from moment to moment without reprisal.

- *Use your non-dominant hand.* On days when self-judgment is thriving, use your non-dominant hand. This shift removes any possibility of your being invested in performance, competency, or outcome. It also makes you more aware of how you use your hands and arms and takes you back to the childhood sense of the enormity of things like crayons and pencils. It invites you into body awareness in the present.

- *Leave work visible and protected for contemplation.* Words and images that emerge from deep in the unconscious sustain special energy for a long time. Leave your visual expressions out. That includes written expressions. Make "display" space as private as possible. If necessary, hang a sign: "No Comments Please, Good or Bad; Nonartistic Dreamer at Work"! It's a reminder for you,

too. Meditate on your work with eyes half-open in a still gaze. Play with the retinal patterns the lines and colors make, with eyes open, then closed.

- *See how your response to the painting changes over time.* There is an invisible cord of energy that pulses between a newly finished piece and me. I usually keep it out until I sense that this pulsing cord has withered. Then I know that the inner, unspoken work I was doing around those images is complete—for now. Alternatively, meditate, with a fixed, unblinking gaze, on the piece. Do this for two minutes a day for a week. Often it takes daily contemplation—even as you walk by—to comprehend the messages from dream creations. On their odd wings, they carry secret messages to our personal awareness.

Create a Free-Form Visual Journal

- *Use a loose-leaf format.* Intrigued at the magical reality of my night life, I began to record my dreams when I was eleven. They told me stories, gave me images that comforted and intrigued. I jotted them in notebooks. When I moved to blank sheets that I later placed in a binder, this was more flexible—and quicker. I could write large or small, add poems, doodle, draw. Using this loose-leaf format, I could keep odd pieces of paper and notes on table napkins as well as dreams written by hand or printed. Clear plastic sleeves hold odd bits of paper.

- *Date your notes.* You'll go in and out of being organized. Pages might pile up for weeks. Date everything, noting significant waking events that preceded or followed the dream. Otherwise,

you will have no idea how to order them later. It's not important to anyone else but it will matter to you.

- *Start each dream on a new sheet.* It's easier to experiment later with groupings.

- *Leave space on the page* within and after each dream to write or draw associations and note anything you, your dream group, or therapist might add later. A friend of mine records dreams in black and later uses turquoise for possibilities that she and her analyst generate.

- *Titling your dream.* One of the most useful habits you can adopt is your dream. Don't fuss about the title. Put down the first title that comes. It might seem silly or shallow, but trust your unconscious: it knows better than your conscious mind what's probably going on. Later, when you have five minutes again, you can track back through the titles. Reading them as they evolve over months is revealing!

- *Start a new journal whenever you run out of room.* Dreams are not concerned about whether a new year is beginning or not. Note beginning and ending dates on the binder.

If we turn to dreams as a trusted guide for inner exploration, we owe them what we owe all valued friends and esteemed teachers: loving attention, commitment, and constancy. Keeping a visual journal is a fine way to tell our dreams we value them.

Treat Your Completed Work with Respect

- *Date, title, and sign each expressive piece created around a dream.* As soon as you have finished, make notes on the back or on a separate page about your experience.

- *Photograph any expressive piece.* You will have an entirely different experience of your own dream art by looking at it through the eyes of the camera. You become a loving witness to your work and will see patterns and secrets not initially observable.

- *Tuck photographs in your loose-leaf visual journal.* If a painting is too large, the photograph will stand in its stead in the journal. Some of my most helpful insights have come from contemplating quick photos of strange dream art!

Expressive Dream Work
in Five Minutes

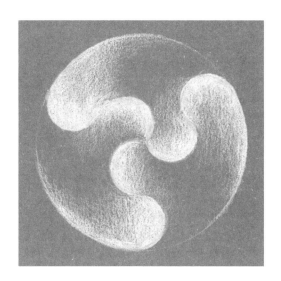

Contemplate your dream and let it contemplate you.

—Harry Aron Wilmer, *Practical Jung*

You would not be reading this book if you were not committed to your psychological and spiritual development. Nor would you be reading it if you didn't sense that dreams and their creative expression have been or will be central to your inner development. So how do you make best use of the little time you need to nourish this commitment?

Most of us usually want to spend more time than we have on dream exploration and expressive dream work. Our outer lives usually need primary attention, and there is little left for inner work. However, souls are hungry but not greedy creatures; they are grateful for and most responsive to crumbs from the table of our attention. More time does not necessarily correlate with more benefit. A focused, quiet five minutes spent with a dream or dream expression can be as helpful as one hour.

You can pursue any one of the practices in this chapter by itself in five minutes or less. You can combine any one practice with any other in the book to make a more extensive exploration of a dream. You also can expand any one practice into a longer session. Ask yourself at the end of each session whether there is anything else you feel the need to express in this or another medium. If you have extra time, do that as well. A painting might engender movements; movements, a painting—and then some voice work. Be open to the unexpected directions toward which your first choice can take you.

Remember to hang up or leave out your expressions in a protected, respectful place for a few days after you complete each. Contemplate them quietly for a few minutes. Often, your understanding of these expressions will evolve and deepen over time.

Most of the practices in this chapter involve imagination, writing, and/or quick paintings. These media are well suited to short time spans. These and other media are also discussed in the next chapters, where you'll explore practices that take ten minutes (or longer if you wish).

You will find that some practices resonate with your current interests or particular dreams more than others. Let yourself choose intuitively. Your body will respond with curiosity to one practice one day and to another on a different day. The same dream might invite one practice one day and a different one on another day. Be alert to the particular synergy between your time, your interest, the practice, and the dream.

If you don't always have a sense of which to choose, let synchronicity choose: open the book and see what the page invites!

Free the Form

writing

A woman showed me her dream journal one day. Her elegant, small script was laid out diagonally across the page. "I'm writing about my waking life horizontally and my dreaming life diagonally!" she declared with a creative freedom that delighted me. What a simple way to acknowledge that dreams operate on a unique timeline that intersects our waking lives!

Just as we tend to tell stories in linear ways, we also usually write dreams in horizontal lines. Like good school children, we take our cues from the margins.

Why not be deliberately "messy" about writing up dreams? Free your writing to take whatever form it wishes—including three- as well as two-dimensional forms.

Ian took a nonlinear dream narrative and decided to write it out first in straight lines and then in whatever form his intuition chose:

> We organize our daily experiences according to our coordination with time, space, and matter. Not so in our dreams. There we seem to link events, not according to space and time, but to feeling and emotion.
>
> —Fred Alan Wolf, *The Dreaming Universe*

The Gods in the Whale (original)

I go across to the [family vacation] island to say good-bye. I embrace my mother in the water. I swim away easily with effortless grace until I get close to shore where the current seems to pull me back. People on shore explain it must be the submerged whale. I finally get to shore and look down into the clear waters. On the floor of the lake is a dead whale. In its mouth are a colored goddess figure, a dog, and a stone god. I realize how valuable

they are and that I've seen them first so I might have first claim. Then it's decided: I say, "Let's get the dog up." Someone dives for the dog. When it's brought up, water pours out of its mouth. I am about to say, "Turn it on its side," but I can tell it needs no further resuscitation. It's breathing.

Ian wrote out a nonlinear form of his dream in less than two minutes:

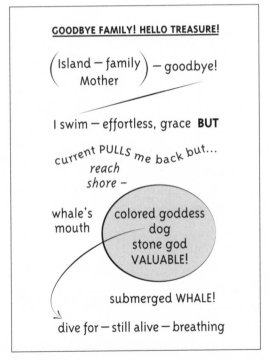

The Gods in the Whale

Ian responded strongly to this nonlinear form: "I hadn't been aware of the significance of the current until I wrote this way. Now I feel the pull for me to go back to family—how hard it is to swim away and be independent. And the form makes me think about my mother and me. We're in the water together—the same emotional lake. I don't know what that means but it makes me anxious when I say it, so there's probably something in it! Then 'god' and 'dog'—the same spelled differently—and 'god-dess.' They *look* like three versions of one thing, three forms of the divine. The form that had *real* life was what I had to dive for—it miraculously came alive again—as though I need to dive down inside and find my spirit separate from my family. The last line seems important now I've written it out separately—it's like a promise: 'It is breathing....'"

Ian intuitively followed some of these basic principles in freeing his dream from linear recording. Let's review them.

- *Forget conventions such as sentences and paragraphs.*

- *Let each word determine its size and writing style according to its relative impact.* Emphasize certain words by writing them in larger script or in a different style from others.

- *Let each word or word group choose its own color.* The colors you choose can be chosen according to their emotional connotation (red for passion or anger, perhaps).

- *Write words with emotional connotations in a way to evoke that feeling*—for example, the word *scared* could be written in shaky script. The word *bang* might be in large red "explosive" lettering.

- *Write words or groups of words according to the physical or emotional geography of the dream environment.* Group parts of the

> Rare are those who can handle [structure] by letting it come, instead of hunting for it or hunting it down, filling it with their own marks and markings so as to consign it to the meaningful and lay claim to it.
>
> —Trinh Minh-ha,
> *Woman Native Other*

dream according to their movement in internal space within the dream or according to moments in time or special feelings. You can even make a map of the dream and write beside each area what happens there. Words that describe events that happened in one place can be in one space on the page. Words that move the events of the dream from one space to another can be written to reflect that movement across to another part of the page. Words that indicate a cardinal direction or flying or falling can visually reflect the movement. Write the dream in a spiral or a square, or concentric or intersecting circles. Let the lines of the narrative meander over the page.

- *Create your own hieroglyphics!* Substitute line drawings for easily rendered figures. A fish can be just as quickly drawn in childlike line drawing as written. Let quick visual forms stand for words. The visual form stimulates a different part of the brain from the written form, a part of the brain more associated with intuition and feeling.

Follow the Form

writing

Allowing the words we use for our dream experience to follow their natural form can be done in many ways. In the previous practice, Ian let his dream map itself on the page according to the feelings that certain words evoked and the actual narrative geography of the dream; other dreamers often choose to let the words in their dreams write themselves out in a pattern or form that actually appears in their dream. Nadia, for example, first wrote up her dream in linear form.

Heart Recorder

I dreamed I saw a tape from a tiny tape recorder that used micro-tapes. Why did I dream such a banal image? Now I remember more of the dream: The tape could be located inside the body near the heart and was designed to record things happening deep inside.

Nadia then worked directly with the form that actually appeared.

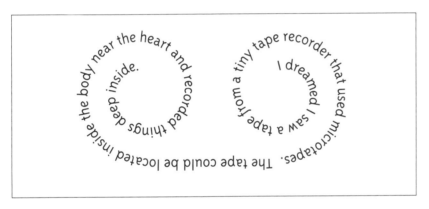

The Heart Recorder

Writing her dream in this spiral gave Nadia a new sense of its levels of meaning: "When I wrote the dream like this—the tape form—I saw the spiral symbol emerge so clearly! It's an important symbol to me. It's my inner growth. It reminds me of Celtic designs that fascinate me—and my Celtic ancestry. It fits the way the heart records its responses, too. I think about this symbol now during the day when I have an

> Our dream images, even if we don't remember them, invade our waking awareness as patterns. By these patterns we live. By not recognizing them, we live unconsciously.
>
> —Fred Alan Wolf,
> *The Dreaming Universe*

emotional response. I just *feel* that tiny tape recorder circling inside. Remembering the image makes me pay more attention to my feelings."

Writers of everything from illuminated manuscripts to advertisements have always known that placement of words on a page has impact. When the message enters into our awareness in two ways—verbal and visual—we receive it more fully.

writing
drawing

Work with Fragments

We don't always remember dreams in images. Sometimes, all we recall is a feeling. This feeling can be a dream reverberating in your musculature instead of in your imagination. If you wake in the night, pay attention to your body. Is it tense? Anxious? Happy? Describe the feeling, the affect, the emotion suffusing your body. Even one word—*excited, anxious, restless*—can be a dream. Note it down. Over time, you'll accumulate a body-feeling record that says something about your silent preoccupations during the night.

Many "non-dreamers" acknowledge they sometimes remember dream fragments. And some dreamers seem to need only fragments. Here are "complete" dreams that others might consider fragments:

- An arm and a hand—hairy.
- Chopin—no images, just Chopin—piano concerto, maybe.
- I'm in an airport. Noisy.

These dreams aren't stories or even fully realized images. They are partial visual or auditory constructs. But they *are* complete dreams and can have import for the dreamer if floated to consciousness. Many people have had rich results from letting a fragment reveal its associations.

Record and work with snippets, fragments, partial images, sounds, tastes, smells, and colors as carefully as you would a longer dream. Most of us live in cultures that equate quantity with value and meaning. The dream culture holds no such values. Working through any sense, they send us telegrams, put one flower in the vase of sleep, offer a single, timely image to our waking selves.

Visit Your Dream Gallery (Visual Fantasy)

Simple visual practices can open up the wealth in a dream fragment. Let's explore a fragment: a hairy arm and hand. Imagine visiting a respected art gallery. You see a six-by-six-foot oil painting of a hairy arm and hand. It's the only painting on display. Stand in front of it. What do you imagine the painter might have had in mind? What are your responses to this giant arm and hand? How would you have painted it? What medium? What colors? What is the feeling or idea it evokes? Taking this evanescent image and giving it artistic focus can deepen your experience.

"Why is it difficult to remember one's dreams?" I asked, prompting Nyima to quip, "Ah, this guy asks everything from head to foot!"

"Because a dream is like the wind, just coming and going," Latu continued, stirring the fire with a stick.

—Robert R. Desjarlais, "Dreams, Divination, & Yolmo Ways of Knowing"

> There is no such thing a small dream, only small dream perspective.
>
> —Stephen A. Martin,
> "Smaller Than Small,
> Bigger Than Big"

Attend the Dream Performance (Auditory Fantasy)

Sounds we hear in dreams take on more significance and meaning when we literally amplify them and treat them as an intentional performance. Let's take the dream fragment: Hearing Chopin.

Imagine you enter an empty room and a famous pianist is playing a Chopin concerto. This performance has been arranged for you and you alone because it has been determined that this is exactly what you need at this time in your life. You sit down in the auditorium. The pianist begins. Your body is filled with the concerto. How do you feel? Who is playing? Why is this especially for you?

embodiment

Become the Dream Image

The woman who mentioned her noisy airport dream to me did it to emphasize the paucity of her dream life. "See? I don't have real dreams! I mean, I'm in airports every week. It's leftover work stuff." However, when I asked her what it *felt* like to be in a noisy airport, how *she* felt, what airports symbolized for her personally and in general, a scroll of associations unrolled for her. She likened herself to a traffic controller at an airport; everything was siphoned through her. She remembered she was the "family bus station" when she was growing up, the one to run interference between warring siblings.

We explored (the Gestalt technique of) *being* the object in her dream, "being a noisy airport." She realized her personal and profes-

sional lives had a common theme: she saw herself as the one to whom everyone came in order to move ahead in the right direction. She felt too responsible, intruded upon, and unable to abdicate her predestined role. She also realized that she unconsciously encouraged this. All this out of a small dream image!

What are some guidelines for embodying a dream figure or object?

- Establish a physical place and body position that represents your ordinary waking self. Having a steady place and physical position to which to return is essential and reflects the importance of the four phases of dream work I mentioned earlier. Dream work takes us into strange realms—and we have to be able to hop on our inner plane and get on to home ground again quickly if we feel overwhelmed.

- Choose either to imagine becoming the dream entity or to actually embody it in a physical fantasy experience that includes moving your body. At times it is easier to simply imagine becoming the object without involving your body. If you are in a public situation or feel private or shy, you might prefer to let your imagination do it all. At others, you might prefer to embody the entity, a more inclusive and often more intense experience, which often leads to sudden helpful realization.

- Consciously conclude your fantasy and return to waking reality.

As you explore this Gestalt technique, you will find yourself amazed and amused at how astute your unconscious is to provide you with often homely yet rich images!

writing

Capture Essence and Hunches

Often, a dream seems ordinary or unworthy of recording. However, recording its essence usually bears fruit; images grow in significance later, particularly in relationship to other images. They become part of a larger pattern that the psyche is forming like a giant mandala. We can never know the importance of one small piece of the larger form at first. Later, we better appreciate it. Capturing essence is crucial. It is a thumbnail sketch. When you don't have a lot of time and you have a long dream, consider these shortcuts. These are not optimal, but they *are* realistic.

- Omit articles; for example, *an, the, a*...

- Omit pronouns where possible; *she, he, we, I, they*...

- Abbreviate names after first mention; for example, *David = D; Mother = M; the tall man in the yellow raincoat = YM (yellow man)*

- Omit transitions; for example, *then; the scene changes.*

- Asterisk changes in time, place, scene, or logic; *Horse rears head, gallops into ocean. * In auditorium—woman singing.*

- If you have an association in the middle of writing, put it in parenthesis and keep on writing; *Weeping child (Carola? Me at 7?) holds up rag doll.*

- Omit approximations such as *It seemed as though ... It was as if ... Looked somewhat like but really wasn't ... Almost but not really.* Put a squiggly line before approximations. For example, *blonde~Aunt Betty* is briefer than saying, *It was someone I don't know but she looked a bit like Aunt Betty except she was blonde.*

- If possible, keep all conversation but omit all the *he said/she said* additions. Begin new lines for a change of speaker and put the abbreviated name on the left.

- Include details that feel charged. If necessary, omit those that carry no overt charge. This is not advisable as a general practice; all dream details have purpose. However, if omitting details makes the difference between your recording the dream and not, then omit. For example, if the room is square, unless the fact that it *is* square becomes important later in the dream, omit it. If the room is shaped like an egg, include it.

- Abbreviate words. Be obvious and consistent; you'll have no idea what marvelous mysteries you have concealed in forgettable hieroglyphics in two months. List repeated abbreviations in the back of your journal, or use the word in full the first time with the abbreviation listed after it.

- Punctuation subjugates elements from the viewpoint of heart and soul that were never meant to be subjugated. Use dashes instead. They are more appropriate for indicating dream structure, logic, and time. Read Emily Dickinson's poetry with the *original* punctuation to remember or learn how eloquent dashes can be.

Often, during recording or working with a dream, we have a body-felt sense, an image, or a quiet phrase that elucidates what the dream carries. Note it, no matter how odd. It doesn't need to make sense now; it will later.

wordplay

Choose Three Words to Amplify

Amplification differs from free association. Amplification circles around and returns to the original point of conceptual departure; free association gallops from one word to the next, without concern for the original concept.

- Take three words that jump out at you in the dream. You might not have a conscious reason for choosing them. In fact, avoid exercising conscious choice. Trust your unconscious. It knows what it's doing regarding its own dreams even if it can lead you astray in waking life.

- Put the words on a page and make a spider web of amplifications to each.

Here, for example, is one word that Nina took from this brief dream and expanded into a word web:

Stained Glass

I pick up the phone and hear Patty [Nina's romantic partner] on the other end. She's telling me about this stunning stained glass window she said we have to buy for our new apartment.

When Nina looked at this word web, she exclaimed, "The image is perfect for the mix of feelings I have about us: I want to be transparent in my emotions with Patty; I feel sadness that my parents' religious beliefs make it hard for them to bless our partnership; I want clear emotional boundaries between us but room for many colors and patterns in our different personalities, artistic pursuits, and spirituality."

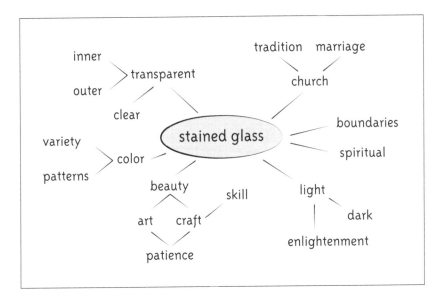

Notice Synchronicities

One of the many gifts Jung gave us was to draw conscious attention to the presence of synchronicity in our lives—those disconcerting "coincidences" that are beyond causal explanation. The dream world often intersects with the waking world in synchronistic ways: an unusual, repeating image of a person, place, thing, or quality (color, feel, shape, sound); an odd, repeating word; a dream image of a place or landscape for which a waking analogue appears within a short time.

Synchronicity does not give directives; it simply highlights patterns. It might accompany a hunch or choice already made. Make quick note of dream events, words, and images that find synchronistic

observation
reflection

parallels in waking life. Do these have a pattern over time? Don't *look* for chance repetition. Just be alert and open to any genuine, uncanny confluences of apparently unconnected yet meaningful events.

drawing
painting

Translate Your Dream into an Energy Painting

Dreams reside in a fourth dimension free of time and space limitations. When a dream enters into memory and body, it moves into a time- and space-bound world. Just as a photograph translates a three-dimensional world into two dimensions on the developing paper, so we translate the experience of the dream. Our memories, emotions, and bodies translate the dream into three dimensions, and then writing translates these sensations into two dimensions.

In essence, through the vehicle of the body, we translate the energy of the dream into personal calligraphy that emerges in line and color. Energy translations usually take less time to do than it does for you to read here how to do them. They require no talent and few materials. You need only a few minutes to yourself (rise early), a blank page, and dry pastels, colored markers, or crayons. Keep a small set of colors beside the bed, together with a pencil and a small block of blank paper. Write the main dream elements on one page and then draw on another.

> Synaesthesia—confusion, interpenetration of one sense with another ... evidently is how imagination imagines.
>
> —James Hillman, "Image Sense"

- After you write down the essence of the dream, close your eyes and replay the dream in your imagination, allowing the feelings, ambiance, and atmosphere to permeate your body. Dreams engender feeling and emotion, connectedness and disconnectedness, elation, despondency—every shade of affective response.

- When you can re-experience the feelings in your body, half open your eyes, let your non-dominant hand choose a color from the set, and use your breath to breathe the energy you are feeling in your body down through your arm, hand, and crayon and onto the page. Use your non-dominant hand or both hands at the one time to choose colors and draw.

- Keep your meditative focus on the feeling of the dream in the body and the images of the dream in your heart. Focus on your out-breaths, using each to direct inner sensations through your non-dominant arm and hand. Continue until you sense that all the energy the dream has generated in your body has been breathed out through your arm, hand, and colors. Then stop.

- Look rarely at and don't be concerned about what goes on the page—keep just enough focus to stop yourself running off the edges. Sometimes your hand will reach for another color if the dream has a change of feeling or direction. You might even turn the page and start a new sheet for a shift in feeling or direction. Don't decide this beforehand. This practice replays the dream through the instrument of your body: let your creative unconscious make these spontaneous decisions.

- When you finish the energy translation, date it, name it (often the same name you have given the dream), and set aside the colors.

- Briefly meditate on the page/s.

- Don't interpret your paintings (for example, "Aha! A black *X!* I must be angry!"). And don't judge them. Free yourself from secret (and confining) hopes that your unconscious has produced a Kandinsky or Picasso. If I were to *critique* from an

artistic standpoint the energy paintings I have done over the years, I would call them "Mess I," "Mess II," and so on. I can't make a contract with my creative unconscious to produce something impressive. I can only step aside so that the "embodied dream" can express itself in two dimensions.

Many dreamers who have experimented with this translation practice have noticed that, at times, their unconscious wants to move on. They might start with a dream but, as they allow the energy of the dream to paint itself, other emotions, other memories arise. Some dreamers choose to return to the original dream image like a meditation practice; they focus on that energy to generate the painting. Other dreamers like to follow the associative energy. Essentially, these two positions are a pictorial analogue of the difference between amplification and free association. We can choose to allow all our associations to derive from the original image or we can allow one image to lead to the next and the next, often moving far away from the originating image.

Both amplification and free association practices have their place, particularly in this genre of painting. Be alert to the inner impulse and stay conscious about the origin of that impulse. For example, if your energy painting is expressing a painful dream, your impulse to move away from the originating image might be a way to avoid staying with something that needs to be carefully tended. However, if you start with a puzzling image and find your unconscious beginning to move you visually through a series of quick sketches, you

"Begin with the exploration of the dream image as you remember it, with the exploration of memory. At a certain point, memory by itself will start producing new images."

—Robert Bosnak, In Michael V. Adams, "Image, Active Imagination, and the Imaginal Level"

might find that it is resolving issues. Experiment with and allow for the possibility of both during any one session.

Take Your Energy Painting into Your Body

voice
embodiment

A quick, helpful way to meditate on your energy painting of a dream (see preceding section) is to translate it back into body language through movement, feeling, and sound.

Place your fingertips on the painting and let them follow the lines as though you were expert at reading the Braille of your own calligraphy. Imagine that your fingers can translate color and line into sound, draw that vibration up your arms and into your throat area, and then let that sound out freely through your throat. You are "sounding" the painting. Different syllables come—you might find yourself making high-pitched sounds for high, thin lines, swooping down into low, guttural sounds for thick lines low on the page, or making staccato sounds for jagged lines.

Your visual awareness will follow a split second after finger and sound movements. Your eyes are not the medium of translation. By using your fingertips to completely take the energy back inside, you can bring the experience of the dream, which was projected onto the page, back into the body for safekeeping and for cellular memory and transformation.

Remove and Replace Images

To better appreciate elements in a painting and a dream, we can remove each, one by one, and

> Only when I make room for the voice of the child within me do I feel myself to be truly genuine and creative.
>
> —Alice Miller, *Pictures of a Childhood*

imagination
notetaking

contemplate the space that it leaves. What is it that this particular brushstroke, color, shape, word, or sentence adds to the whole of the painting or dream? Patricia, for example, wrote her dream out so that each sentence contained only one major element; in this way she could experiment with removing each one by one.

Ceremony

I am traveling with older Native American women. We have to go do a special ceremony somewhere. I am in the back seat. I have a small ceremonial pot with me. I wish I had brought some herbs. We arrive and begin the ceremony. Someone knows which way east is. Some of the boys in our group are rebellious.

Then she took each sentence and asked herself, How does the feeling or the mystery of the whole change when I remove this element?

When I omit	I miss a sense of
The American Indian women	The quiet sacred feminine energy
Traveling to do a special ceremony	Sacred purpose
The back seat	A sense of being led
My ceremonial pot	My unique role in the ceremony
One who knew where east was	A wise elder with superior knowledge
Rebellious boys	Balance, levity

Removing each element in turn to see what quality is lost from the whole helps us appreciate each element's contribution.

Remember Your Image through Simple Sketches

Sometimes I actually want to "re-member" the image through a more representational drawing or painting. When I do this, I don't want to feel bound by my capacity or incapacity to draw. I still have trouble unprying the talons of my judging mind; they instinctively rip at the soft underbelly of my self-acceptance and creativity. One way I loosen their grip is to use my non-dominant hand or both hands. Then I can't even *try* to paint or draw "well."

drawing

When you render particular images, follow the same ritual you do for energy paintings with some differences. Close your eyes and go within. Allow the dream to replay until you find one part that draws your energy and attention more than any other. This image might not seem important or meaningful. Work with it, nevertheless. You are attracted most strongly to this image for a reason you probably won't discern for days, months, or years.

When that single image coalesces in your imagination, pick up a color and express the essence of that image with deliberate, childlike simplicity. Bodies become stick figures, ovals, or crosses; faces become round circles or eggs with dots for eyes; houses become boxes with triangles on the top. Everything will look as though it has been drawn by a six-year-old.

Perspective in dreams is usually fluid. So ignore perspective when you draw. How, for example, can I be leaning on someone's shoulder at the same time as I am holding his opposite hand without lifting up my shoulder? In dreams, we do these things effortlessly. There is no limitation on time and space in dreams, so don't limit your painting. If a figure *feels* big in the dream, make it big on the page, even if it ends up

bigger than the house it occupies. That's the way your dream felt and your hand moved. Sometimes, I even have the same figure appear twice on the page because s/he appears at different times or places in the dream.

When you feel finished, hang the painting where you can see it (and no one else can—at least, no one nosy). See how your response to the painting changes over time. An invisible cord of energy pulses between a new painting and me for hours, days, sometimes weeks. I usually keep the painting up until I sense that this pulsing cord has withered. Then I know that the inner, unspoken work I was doing around those images is complete—for now—and I take the painting down. You might like to meditate, with a steady, unblinking gaze, on the painting for five minutes a day for a week. Alternatively, keep the painting up until the next is completed. Find your own way of knowing when your work with the painting is finished.

These paintings do not *represent* dreams but *present* dreams. They constitute your personal visual language, which is evolving over time.

drawing

Do Simplified Sketches of Dream Animals

Our ancestors have drawn the spirits of animals that were important to them in innumerable ways—from the Lascaux cave drawings to the stylized, abstracted figures found in Native American art, from the abstracted dot forms of certain Australian aboriginal tribes to the elongated carved figures of certain Irian and African groups.

Dream animals carry so much energy that presenting their qualities and forms in two dimensions and color is important. You may be sure that you can't draw an ant or an eagle any better than you can draw a

person or a building. It doesn't matter. As with our ancestors and shamanic tribal groups, the spirit in which you approach the painting is more important than the rendering.

If you really want to make an accurate representation of the animal, don't draw freehand. Go to the library, borrow a book on animals, and photocopy or trace the animal. However, if you want to express the feeling of the animal, the spirit of the animal, rely on the wisdom of your non-artist's hand—the non-dominant—to express the animal's essential quality. You will probably end up with something that your inner critic will think is childish and humorous. Tell the critic that its assessment is irrelevant. What is important to you is the directness, honesty, and unapologetic intensity of your childlike response to this animal.

Upset your overtrained mind. Draw the animal from the top looking down. Draw the animal from the back or from underneath. Draw the animal's eye or tooth. Draw whatever part of the animal captures its essence for you. Don't try to draw a profile of the animal with all the proportions correct! Color it all in if you like, the way a child fills in all the spaces contained by lines. Make up patterns that fit into the different body parts—torso, head, legs, tails, wings—of the animal. Draw your primitive, uncensored response to the appearance of this animal.

Remember: you are not attempting to replicate *facts* about the animal but expressing a *feeling* or *essence*.

Make a Dream "Eternal"

When I have only a few minutes to explore a dream, I tend to dismiss it. It suits me to view it as unimportant. My hurry colors my

wordplay

perspective; I am more likely to view the dream events as merely isolated, unimportant, inexplicable, or odd.

James Hillman suggests a way to shift from a temporal perspective to an eternal, from the particular to possible wider implications of a dream. He suggests we experiment with "eternalizing" the dream:

- Add *when* and *then* wherever you can in the dream narrative.
- Change wherever the word *when* appears to read *whenever.*
- Reverse the images to explore alternative causal connections.

Hillman notes that adding an "-ever" suffix eternalizes a connection that might otherwise be easily passed over. It strengthens a hidden pattern (when/then) and lets us imagine that this pattern is *always* repeating in our life or in our psyche. Let's notice what happens to Julia's dream:

Freefalling (original version)

I am watching and then become one of a group of people falling to earth from the stratosphere. We're learning how to use the air currents as we freefall. We're not flying. I pull an imaginary cord on an imaginary parachute and break the fall at the last minute.

Freefalling ("eternal" version)

Whenever I watch, *then* I become one of a group of people falling to Earth from the stratosphere. *Whenever* we learn how to use the air currents, *then* we freefall. We're not flying. *Whenever* I pull an imaginary cord on an imaginary parachute, *then* I break the fall at the last minute.

Freefalling (reversing when and then)

Whenever I become one of a group of people falling to Earth from the stratosphere, *then* I watch. *Whenever* we freefall, *then* we learn how to use the air currents. We are not flying. *Whenever* I break the fall at the last minute, *then* I pull an imaginary cord on an imaginary parachute.

Julia reacted to "Whenever we freefall, then we learn how to use the air currents." She thought about how often she tried to control situations in her family life and work. She wondered if she could "freefall" more in daily life, trusting her capacity to learn how to "use the air currents." She found encouragement: "Whenever I pull an imaginary cord on an imaginary parachute, I break the fall." Over the next months, Julia worked with these two images. Before she entered a room for a meeting, she would use the threshold to remind her to freefall, to trust the air currents, to pull that imaginary cord if needed. She learned to calm herself before stressful situations by using these images. These changes in her imagining and behavior were a healing influence on her life.

Get Specific

wordplay

Being specific with dream images can also be helpful, as James Hillman points out. He underscores the risk of viewing our dreams so symbolically that we miss the personal point. He suggests we experiment with "singularizing" the dream by using the word *only*. Let's see how Chris used this practice with a dream:

Unknown Territory

I'm walking or driving. I'm responsible for my mother or my daughter. It's half-known territory around a public building or hotel but I can't find the entrance. You're not allowed into rooms that belong to certain people.

Chris commented sadly that this was typical of her: she never felt confident in public situations. She always felt responsible for and inadequate to the situation. Recognizing she was making a lot of "always" and "never" generalizations, Chris got specific using the "only" approach:

"Only when I am walking or driving do I not know my way around."

"Only when I am responsible for my mother or daughter do I have trouble finding my way around."

"Only public institutions or hotels seem unfamiliar."

"I only have trouble entering public institutions or hotels."

"Only when people have certain rooms am I not permitted to enter them."

This specifying had practical outcomes. Chris identified specific situations that concerned her. She realized that she grew anxious taking both her mother and young daughter to new places; neither could walk far. She decided that when she had either with her, she would phone ahead about parking—a practical outcome! Chris also better understood her uncertainties. She had felt at sea in public ever since she had

changed school systems when she was eight. She resolved to be as patient with herself as she was with her daughter and mother; she would not expect herself to be perfectly competent in unfamiliar situations.

Getting specific breaks down the insurmountable into the manageable. Too often we ask ourselves: "What's the most I can do to change this situation?" More helpful, often, is the "taming power of the small," as the *I Ching* describes it, that invites us to consider: "What's the *smallest* change I can make?" Small shifts can be as far reaching as a butterfly's change of direction, which can actually alter weather patterns on the other side of the Earth.

Use Contrast

Contrast can be used with any part of a dream—another simple idea from Hillman. The trick is to change one thing at a time.

imagination
notetaking

- List each important element in your dream.

- Take each color, figure, place, activity, and so forth—and imagine a different, *contrasting* image that the dream might have used. List it if you wish.

- Become aware of what shifts for you internally when you consider giving up the original element for the contrasting element. What it is that you *miss* about the original element that this contrast brings to your awareness?

- Briefly write out or speak aloud the dream now using these descriptions of what the original image evoked.

This is simpler to do than it sounds, as you'll see in this next dream.

Tara lists contrasts in parentheses. There were other contrasting elements she could have chosen, but the first one that came to mind was enough to put her more in touch with the value of the original image.

Bicycling with My Mother

I am *bicycling up* the side of a mountain. I am with my *mother* who is much *younger* in the dream. She is telling me about some meeting where there was a speaker who brought a *lion* as a pet. We reach the *top* of the mountain and sit on a seat.

Contrast Notes

What's different about *bicycling* from, say, *driving?*

Slower, more of my own physical energy needed.

How does the dream change if I imagine driving *down,* not *up?*

Much more effort to ride up—have to want to do it.

What's different about being with my *mother* as distinct from my *father?*

Most unlikely thing I could do with my mother—she's inactive.

How would it be different if she were her *real* age, not *younger?*

Less energetic.

How would the sense shift if the speaker had brought a *mouse,* not a *lion?*

A mouse is scared; having a pet lion gives the speaker power.

Would it feel different if we had reached a *valley,* not a *mountain?*

Sense of mastery and relationship with sky—king of the mountain.

Tara then told herself her dream narrative out loud using the qualities she had discovered about each element.

Restated Dream Essence

I'm doing something I like. It's a lot of effort but I'm accompanied by an unfamiliar, young, energetic, maternal side of me who tells me about encountering a powerful, public man who can command obedience even from the king of the jungle. When we reach our goal, we rest in a designated place.

After she retold the dream, Tara commented, "Sounds like my professional life. I work hard but I like it. I need my energetic inner maternal energy (to take better care of myself). The man sounds like our CEO. I need to be alert to his power—he doesn't like to be challenged. He's a king in the software jungle. I need to take time to rest."

By experimenting with alternative imagery, we appreciate the subtle choices our creative unconscious makes. Our unconscious is meticulous; it knows just what image to use to create just the desired effect and affect.

imagination
writing

View Life Events as Dreams

Were I to disguise the players and write a novel about the extraordinary people I have met and strange and miraculous tales I have heard in my office, no one would believe me. The tales are too incredible. Outcomes are perfect but so unexpected. Synchronicities—those wild, timely, acausal coincidences—abound. And then there are the unbelievable, lovable characters. All these would never go down in a novel!

Life *is* stranger than fiction. The fiction that best approximates life is the genre of magical realism, the tradition of Gabriel García Márquez, of Isabelle Allende. A writer friend recently published a short story in a highly regarded national magazine. She presented the story as a dream, her way of making its confluence of rare events believable. However, she and I knew that every word was true; she had lived those events.

We can better appreciate certain events in our own lives and approach them with more openness to their larger significance if we look at them as dreams. We can permit the impossible, the acausal, the out-of-time, the unexpected, the miraculous solution, the archetypal entry of dark characters.

Life situations don't even have to be extraordinary to be constructively viewed as dreams. Even puzzling, ordinary events take on a different slant when we imagine them to be dreams. However, waking events that seem to respond best to conversion into "dreams" are those that are puzzling, hurtful, bizarre, synchronistic, joyful, haunting, baffling, or repetitive. We can shift emotional, philosophical, and psychological orientation to these events by simply changing the genre in which we narrate them from history to dream. Notice the shift in your response to the following event when it is related as a dream.

Report of Life Event

Yesterday, I rose early and went to the kitchen to make tea.
I turned on the kitchen light and one of the bulbs blew. Then
the kettle didn't heat. I tested it on another burner and it heated
fine there. It was unexpectedly dark because it was about to rain.
I thought I might be coming down with a cold.

Here is the event reframed as a dream:

Dream: Nothing's Working Right

I dream that I get up early and go to the kitchen to make tea.
I turn on the light in the kitchen and a bulb blows. Then the kettle
doesn't heat—I test it on another burner and it heats fine there.
I think to myself *in the dream* that the burner must be defective.
The whole dream is pretty dark because it's about to rain. I think
that I'm coming down with a cold. *Then I wake up.*

The import and tenor of the event deepen when I view this series of
minor events as a dream. And, as a matter of fact, the "dreamer" learned
something just writing this out as a dream; he realized "the dream"
could be an analogy for his body: "I'd had minor physical ailments and
I hadn't paid any attention to them. And I *knew* I'd been overusing my
internal circuits—they'd been burning out or cutting out on me unex-
pectedly. I'd been too busy at work and coaching the team—spending
more energy frustrated with those minor failures in my body than
doing anything constructive about them. Hmm!"

Let's review the steps for turning a life event into a dream:

- Declare the genre: "Dream."

- Give it a title.
- Begin with: "I dream that. . . ."
- Add: "In the dream" every so often.
- Conclude with: "And that's the end of the dream."
- Put it in the present continuous tense.

If we use this technique too often or overidentify with it, we risk putting ourselves at the center of things too much, leading to an exaggerated, puffed-up belief that events are sent to us personally as "teachings." Certainly, we can learn from all events if we are "continuing education" students of life. However, we deceive ourselves if we believe we are singled out as protagonists in all life events.

We are usually merely players in situations. When we turn a waking event into a dream event, we consciously make ourselves key players. We intentionally—and temporarily—treat the event as something that has been provided for us to learn from. This "dream" perspective always differs from the waking perspective because we translate the event from taking place in a temporal context to an eternal one. The resulting "dream" is not operating like the waking event but becomes an informative, active myth we develop for our own education. By borrowing events from waking life, we better understand what inner patterns we bring to those outer events.

4

Expressive Dream Work in Ten to Fifteen Minutes

"You can say that each ladle full of the water of life is a dream. That's what a dream is. Every night, we get ... a sip of the water of life, and, if we understand the dream, we are vivified."

—Marie-Louise von Franz, in *The Way of the Dream*

Some dreams are natural fairy tales; some are natural poems; others are natural plays or choreographed dances; yet others are natural paintings or sculpture. Some dreams are so fluid that they just invite any medium of expression. In this chapter you'll find ways do expressive dream work in less than fifteen minutes using many different media and genres. Once again, each practice is designed to be compatible with any other, so feel free to combine them. Expressing a dream through several media can deepen and expand awareness of its significance in our waking lives. Allow your intuition and your body resonance to choose a particular practice for a particular dream. And be sure to leave your expressions in a special, private place for ongoing contemplation until your connection with the pieces feels complete—for now.

voice
writing

Turn Your Dream into a Fairy Tale

In fairy tales, fact and fiction form the cross-fibers of the finely woven fabric of story. A fairy tale is neither one nor the other exclusively. Dreams, too, belong in this middle realm between inner and outer reality. We recognize the fantasy element of dreams and also can be quick to dismiss it. Yet we are just as quick to dismiss "unimaginative" dreams *because* they have no fantasy elements. Both positions are extreme and exclude the middle realm. Even the most ordinary dream can open a wide window onto a field of fantasy.

How do you turn a dream into a fairy tale? You can experiment with the following suggestions by speaking your fairy tale out loud or by writing. (Later, you might even like to illustrate it or do a collage to accompany it or respond to it. You could also dramatize it!)

- Begin the dream classically with: "Once upon a time...."
- Give each important element—each character, animal, house— a name and capitalize it.
- Exaggerate. What is small in the dream, make very small; what is large, make exceptionally large—a book, a room, a nose, a body, a noise.
- Embellish or invent all settings.
- Make up what people look like, what they are wearing.
- Add *always* and *never* wherever you can.
- Make up dialogue.
- Use as many *descriptive* (using the five senses) adjectives and adverbs as possible—at least one adjective for each noun and one

adverb for each verb. For example, the *tall* Queen *quickly* opened the *heavy, stained* book.

- Put the story in the past tense.
- Give the tale a title that would intrigue you if you were six years old.

Paloma had the ultimate banal dream: a taxation dream! It defied interest and certainly didn't fill her with uncontained curiosity:

Looking at Private Tax Returns

I am sorting tax returns in an old upstate New York house. The returns are odd. They have special contents. I come across M. and C.'s [the dreamer's sister and brother-in-law] and am careful not to read anything on it. I don't want to intrude on their private life.

Paloma turned her dream into a Fairy Tale. It is reprinted as it appeared to her and with no editing. It took her *two minutes* to write.

The Inquisitive Queen

Once upon a time, there was a Queen. She lived in a wonderful old rambling wooden palace in the middle of the forest. She was rather lonely there. She was always very curious about her subjects. Her subjects had always been afraid of her.

Because she had never been good at talking to them, she ordered her First Minister to bring her the records of the goods that each subject had brought to the castle as payment for the land that she allowed them to farm.

Her Minister warned her this was the one thing she was forbidden to do as Queen. However, she was very strong and thought that she was above the law of the land as she was its Queen. She read from the large book.

As she lit a candle in the approaching dusk so she could read better, she suddenly saw that what her sister, the Princess, and her husband, had given her as their annual tithing was a measure of the curse she had put on them when she banished them to a hovel in jealousy so she could be Queen.

She suddenly realized that, in ten years time, her own curse would return to her and she would be banished.

> What walks through my dreams is not actual, other persons or even their soul traits mirrored in me ... but the deep, subjective psyche in its personified guises.
>
> —James Hillman, *The Dream and the Underworld*

What had started life as a banal dream about a tax return now suggested to Paloma that she was more envious of her sister's good fortune than she realized and had emotionally withdrawn. Paloma also saw that she had been ready to dismiss the dream because of its lack of magic and fantasy. She had wanted to reduce the dream to her daily reality instead of meeting the dream on its own terms: meeting the imaginal *with* the imaginal.

writing

Turn Your Dream into Your Life Myth

When we identify with who we are or what happens in our dreams, we delude ourselves. We take our dreams too literally: "This dream about making love to someone other than my spouse means I need to have an affair." We translate the content and morality of the dream directly into our waking world.

We are equally at risk if we reduce the dream's importance, saying, "It's only a dream. This powerful woman who makes love to me and encourages me to return to my artwork is just a product of the movie I watched."

We keep the dream from taking up conscious residence in our body. To avoid these extremes, imagine that the thin ribbon of a dream you had this morning (say, about solving a problem with your child) were the only dream you had or would have. What would it mean to you that *every* morning of your life you woke remembering solving that problem with your child?

Treating your dream as eternally true, an exercise James Hillman suggests, turns your dream into a life myth. It keeps the dream symbolic (clearly you do other things in your life besides solving problems with children). It also ensures that you don't dismiss the dream. So it provides you with a third way to look at it. By treating it as myth, you can have what Edward Edinger calls a "conscious dialogue" with the image or symbol. This allows the symbol to release and transform psychic energy—with your conscious engagement. A simple way to apply this approach is to:

- Title the dream: "My Life Dream."

- Open your first sentence with: "Every morning I awake having dreamed that. . . ."

- Add *always* and *never* where you can.

- End your write-up with some statement such as, "And I am destined to dream this for the rest of my life."

Rebecca used this approach with a simple dream:

Getting Off the Roof

I'm on a roof that is being repaired. I want to get off the way I got on but I get nervous. I know I need to calm myself before I get off. However, the man who's repairing the roof starts to push me. I yell at him to stop but he keeps pushing. I am baffled and enraged and scared. I spot an open window and crawl into my mother's room.

My Life Myth: Getting Off the Roof When I Am Ready, Not When I Am Pushed

Every morning I awake having dreamed that I am on a roof that is being repaired. I want to get off the way I got on but I *always* get nervous. I know I need to calm myself before I get off. However, the man repairing the roof *always* starts to push me. I *always* yell at him to stop but he *always* keeps pushing. I am *always* baffled and enraged and scared. However, I *always* spot an open window and *always* crawl into my mother's room. *And I am destined to dream this for the rest of my life.*

Rebecca was fascinated with this result. She recalled many incidents where she had capitulated to an outer authority's timing that had nothing to do with her inner timing. She had even acquiesced to having a second child when still debilitated from a difficult first birth. She remembered the false bravery she had adopted, having grown up with two adored older brothers for whom she dared anything in return for their company. Rebecca also saw that if she were, indeed, destined to dream—and live—this for the rest of her life, she would be very, very

tired before she reached middle age! She realized she needed to move more into the realm of her mother (a quieter, reserved, slower-moving woman). There, she could escape both the fear of going against her self-knowledge and the struggle to maintain her position against inner forces that pushed her beyond her limits.

This practice only takes a little longer than merely writing up the dream but, as Rebecca's work shows, it allows the dream to be viewed through a different, timeless window.

Unearth the Natural Poetry in Your Dream

writing

When people walk along the stone path, open my Western version of a *torii* gate, and walk through the Japanese garden to my office, their dreams accompany them. I can almost see the air around them change when, in that quiet, interim, garden space, they allow the images from their night worlds to resurface. I invite people to tell rather than read me their dreams, although some, for good reasons, prefer to read. I rarely just read their written words; I like to *hear the images*. We bring a feeling tone to our dreams when we tell them. Forgotten dream images return even as we speak. When we tell our dreams, our cadence is often poetic. The dream evokes a different rhythm of speech because its logic is soul logic: a pause as a powerful image permeates the imagination and body again; a rise in inflection as the image expands the heart, catches the breath, carries feeling to an unexpected place.

Many dreams are natural poems. Others are pure story. Some are both. The following dreamers wrote out their dreams in linear narrative form and

> Most poetry ... is printed on the page in a form that forces the eye to slow itself to the cadence of the images.
>
> —James Hillman, *The Dream and the Underworld*

then broke them into free verse lines "to force the eye to slow itself to the cadence of the images," as Hillman says. They weren't trying to write good poetry—an ambiguous term even in the finest critical circles. While it is debatable what good poetry is, "good" poetry *writing* leans heavily on the poet's capacity to release images from inner worlds so that the images can incarnate in bodies of word. This requires courage, honesty, integrity, and connection to a source of inner cohesion: the soul. Skillful use of poetic devices is not needed for dream work. Here are simple guidelines for finding the poem in a dream:

- Omit detail that carries less subjective force.

- Omit words that are approximate, redundant, ineffectively repetitive, or vague.

- Use short lines.

- Keep sense descriptions (tactile, visual, auditory...) where possible.

- Change the tense if it's awkward—from present to past, or past to present.

- Change the form from third person *(he/she/it)* to second person *(you)* if there is one other dream character involved. This can add immediacy by bringing a conversational voice to the poem.

- Break lines by phrasing; meaning units; a change in imagery, time, place, direction, intent; or breathing place.

- Convert paragraph breaks into new verses.

- Leave out explanations.

- Remove the uncertainty ("The room looked a bit like a cave" becomes "This cave."

- Omit modifying words such as *very, almost, quite, somewhat, most, really, highly, extremely.* Be absolute! Exaggerate.

- Omit qualifying words that are judgmental and/or abstractions such as *beautiful, ugly, wonderful, terrible, meaningful.* Only keep those that add to the charge of the poem. A dream image can usually convey the same feeling as the judgment word.

- Stop when the poem *feels* complete. This might not be where the dream stopped. Poems know when they are whole. You are not bound to be exact to the dream. In fact, the poem might dream the dream onward, take over unexpectedly. Don't fight this. It is an evolving gift from your imagination.

- Leave out parts if you feel they don't belong or feel they are not salient to the particular images you are developing.

The following dream poem captures unfettered, metaphoric truths that sprang from a dreamer's soul. Claire, the dreamer, was deeply moved by it. It permeated her awareness for days. The first version she wrote on waking. Several days later, Claire added the underlining and line breaks:

Touching Jupiter

I am dressed *in a* large *black cloak. / Rick* picks me up and *carries me. /* It is night. / There is no other scenery. *I collect the edges of my cloak so they don't drag in the water* on the ground. / I am full of *delight. / We* stand and *look up at Jupiter. /* It is the *largest,*

most luminous and beautiful planet I have ever seen. It has *other planets* and stars spinning around it *making saturnian-like rings /* because they are spinning so fast. It is an entire *universe!* I am overwhelmed with the sight and with its beauty.

Then suddenly the whole *universe around* Jupiter *and Jupiter itself / move upwards across the night sky /* with rapidity.

Then quickly, it moves away from this new position and *shoots* down *to earth* and *lands / at out feet, /* appearing as a luminescent, incandescent, *blue ball of light /* about two feet in diameter. I cannot take my eyes off it. *It wants me to touch it. / I am overcome with awe and terror /* and only with the greatest difficulty and with the sense of Rick's support as he stands behind me, do *I utter 'Yes.' /* The effort of saying 'yes' is so strong that it wakes me.

Here is Claire's free verse version developed from her underlining and line breaks. Be open to your own response. How does this version affect you?

Touching Jupiter

Night.
He carries me.
I gather the edges of my black cloak
away from the water.
Delight.
We look up.
Jupiter.

Planets and stars

spin rings of light,

a universe.

The universe and Jupiter

move swiftly across the sky,

land at our feet,

a blue ball of light.

Jupiter silently says:

"Touch me."

With awe and terror

I utter, "Yes."

Make a Poem out of a Challenging Dream

writing

If you're not sure whether your own emotional response to your dream might change by seeing it in a new form, work as Alan did with this dream he had one year after separating from his partner of many years. It was a painful separation, and Alan had been feeling heavily despondent about his failure to keep the relationship together. He believed there had to have been something extra he could have done. His dream gave him this gift:

Trying to Please Bob *(narrative version)*

I fix dinner for Bob and also arrange for the Guarneri Quartet to play. Bob is unappreciative. He wants to know if they are going to play something he has already heard them play and doesn't wait for me to sit down to join him to eat but finishes immediately. When

I am pushed to mildly protest that he didn't wait for me to eat, he says he thought he was doing me a favor by coming to dinner so I wouldn't be lonely. I am furious and say that Chris [Alan's oldest friend] and I gave up a good party to do this for him.

Alan believed this dream was giving him a gilt-edged message on a sterling platter. It was laying to rest his anxiety about whether there was anything else he could or should have done. He saw that, no matter how he might have tried, his partner would never have been satisfied. He paid homage to this dream that extinguished the embers of self-doubt by rearranging it into verse form:

The Guarneri Quartet

I fix dinner for you,

arrange for the Guarneri Quartet.

You want to know

if they are going to play something

you have already heard.

You don't wait for me

to join you but eat quickly.

When I protest

you didn't wait,

you say

you were doing me a favor

by coming—

so I wouldn't be lonely.

Even the Guarneri is not enough!

Dream poetry can simplify, clarify, reach for essence, create something psychologically strong. The very act of putting the dream in poetic form allows for slowed-down, quiet, nonreactive contemplation of images. Dreams are often poems and poems, waking dreams. Let one form nourish the other.

> The text of a dream may be similar to that of any poem, painting, or narrative: "a system of internal energies and tensions, compulsions, resistances and desires...." But it may also be a single image ... to be enriched....
>
> —Sylvia Brinton Perera, "Dream Design" in Nathan Schwartz-Salant and Murray Stein, eds., Dreams in Analysis

Look at What's Missing

Traditional Western art refers to "negative space" in a painting—the space around the main painted or sculpted object, the air around the vase of flowers. *Negative* has two other common meanings: something undesirable or unacceptable; and strips of film negative. Both of these connote "what is *not.*"

imagination

Eastern art values "negative space" for what it *is,* rather than for what it is *not.* It values open space in a painting, not for how it sets off what is painted but for its own "positive" role. This space is sometimes referred to as *ma* in Japanese tradition, as Michihiro Matsumoto explains in *The Unspoken Way.* Among its complex meanings, it connotes a potential realizing itself, an eternal moment unfolding, a deep power present in silence. It is an empowering mystery, whose silence, empty time, and space is infused with the eternal present.

Ma can be *felt* in dreams. Notice what is *not* in your dream—the missing link between two scenes, the "illogical" sequence, the dream with no end, the voice without a body, the room you entered without a door. These apparently "negative spaces"—unfilled by sequence, location, or logic—are replete with energy. What we associate to that

energy is ours to discover. *Ma* can perform paradoxical functions in dreams. *Ma* is a way for a dream to present the impossible—being present in two timeframes, two bodies, two genders, two places, two belief systems.

Let us look at the ways we can explore the presence and functions of *ma* in David's dream. Many places in this dream are imbued with paradoxical mystery—if we can just lift the dream narrative from the burden of rational logic. David explored the *ma* in this dream by highlighting words that opened into the mystery, to the place of worlds and unseen insights unfolding:

Ma in the Open Heart Dream

I'm doing open heart surgery on some man *but* I'm not a doctor. *It doesn't seem to bother me.* I'm doing it with someone else *I can't see.* I tell the other person to be careful not to cut too close. *Suddenly,* I'm talking with the patient in her room. *She's a woman now.* I tell her it was a success *but* she is going to die anyway. She *doesn't seem upset.*

We can imagine all kinds of elements that could fill these mysterious spaces. However, the point is not to fill them with rationalization but to dwell in their mystery, to imagine what it might be like *in* the spaces. For example, rather than trying to *explain* why he might be an unqualified doctor, David imagined how he would *feel* doing something for which he had no formal training.

As the doctor, I see myself floating from the operating theater to the room, dropping my theater gown behind me. As the patient, I

feel a sense of inevitability about my death—as though the operation allowed me to find my inner femininity. There's a sense of fate—the operation is necessary—something that's been hurting has needed transformation. Somehow whatever is going to die is necessary and inevitable—maybe some old way of being?

David rarely filled the spaces with rationales that would provide the narrative with "logical" transitions across time and space. Rather than reducing the mystery, he preserved it and respected it. Other than avoiding rationalization and analysis, there are no set ways to explore the mysterious spaces in dreams. Exploring *ma* with loving respect is simply to come away from a dream still feeling the mystery—but feeling it more richly.

Write Your Dream Haiku-Style

writing

Most haiku carry the essence and passion of a simple action or event and place it within a specific yet timeless context. A woman's hand, trembling as she holds a cup of tea, is juxtaposed against an autumn tree. She weeps. Here are no explanations, no causes, no expanded stories. We do not know why she weeps; we know *that* she weeps. We do not know why she trembles; we know *that* she trembles. Does she tremble because she is cold? We know it is autumn. Does she weep because it is autumn? Because her lover is not there?

The woman's tears remain forever a mystery in exactly the same way our dream images remain mysteries that carry the charge of the known act or image and the mystery of the unknown history behind act or image. They carry *ma*.

So the haiku style is uniquely suited to many dreams. It is one of the loveliest, least intrusive ways to record a dream image that might have appeared alone or as part of a bigger dream.

A traditional haiku arranges seventeen Japanese syllables in three lines of five, seven, and five. Some translators keep to seventeen; others do not. It is not important that you abide by this rule. You are not entering into a haiku writing contest; you are entering into the essence of an image. You can, however, abide by the *spirit* of haiku. You can keep to around three short, simple lines.

Haiku focuses on sense detail, locating a feeling in a minimalistic, strongly etched image. It is a parenthesis in eternity. The poem often indicates season by the mention of a plant, flower, or weather condition. You do not need to do this, but if you stay with one or two natural images you can gently sustain the feeling embedded in the dream, the essence of which you bring to this poem.

Haiku-style poetry is well suited to dream images we might dismiss because they are too short to be a "story." The following dream was one the dreamer was ready to dismiss; she believed she had lost too much of the dream to explore it creatively. When she altered her viewpoint and realized that, rather than looking at what she had lost, she could look at what she had saved, the haiku emerged.

Night Ceremony

Some kind of ceremony. It's a beautiful night. There's a moon— and lots of clouds. It's pretty warm, so I think it's spring or early summer. This beautiful woman looks over at me and we know we are supposed to go through something. To mark this somehow, she

lights a candle and walks slowly over to me. I wake up before I find out what we are supposed to do but I have this sense of a beginning.

Haiku Version

> The moon rises through blue clouds
> in spring. Lighting a candle,
> you move toward me, smiling.

In this next dream, the dreamer selected one part on which to focus:

Iris

I am in some kind of department store. I am too hot, so I walk out the back door past some sort of store security guard. I find myself in this really beautiful setting. It's early morning and I'm in a clearing in the forest. There are lots of iris blooming all over the grove. They are a sort of purple blue like a bruise color. The air is really still.

Bruised Iris *(Haiku-style)*

> Dawn. In the dry grove,
> iris are still,
> mauve as eyelids
> bruised with dreams.

Haiku taps into essence, into the candlelit place where temporal and eternal meet for one brief, exquisite moment—which is, after all, where a dream resides.

Draw Mandalas after Dreams

drawing
painting

A mandala provides a gestalt, a wholeness that comes straight from or speaks to the center of the Self and our deepest understanding. Unconscious mandala forms (sacred patterns enclosed in a circle and drawn as a spiritual practice in many cultures) are often embedded in dream images. If you review your dreams, you can probably find mandala forms, particularly if you look at a dream image from a different angle. For example, people dream about cities with roads radiating from the center, cut gemstones, flowers, actions that move in mandala forms. Mandala images from dreams vary widely, for example: "My friend has a pot with crisscross design"; "I'm dancing with my husband in circles"; "My diploma has a round design"; "I've lost my sapphire ring"; "Something about the wheel of my car. . . ." Some of these examples are complete dreams; others have been taken from larger dreams. Each contains a mandala. Drawing mandalas, whose conscious practice in the West we owe to Jung, allows us to pay homage to images of wholeness, completeness, big *S* Self, images that take us home to our inner core. Mandalas don't have to be complicated. In fact, simple mandalas are often more powerful.

- Use a small piece of square paper (white or black) and black or white pencil.
- Draw a containing circle using something circular such as a cup.

- Play with drawing curved lines or geometric shapes within the circle.

- Draw equilateral triangles and squares within the larger circles. Use a ruler or the straight side of whatever is close by.

- Connect the corners of those lines with other corners.

- Make circles inside the triangles or other squares.

- Alternatively, draw free-form within the containing circles.

- Color the contained areas if you wish with your preferred medium. Don't attempt to make your mandalas perfect.

> "Dreams always point to the inner center. They are like hundreds of forms all pointing to the inner center. Every dream is an attempt of nature to center us, to relate us again back to our innermost center, to stabilize our personality."
>
> —Marie-Louise von Franz, in Fraser Boa, *The Way of the Dream*

Sound a Dream Mandala

voice

When you finish making a mandala, imagine that its lines are raised like Braille. Let your fingertips slide over the lines slowly, slowly, with your eyes half-open. Let your body take in the small form of the mandala and magnify it with your breath. Imagine that the mandala form is translating itself into a three-dimensional form in your body, a form that takes up residence in some protected corner where it is needed. Let your voice "sound" the mandala by letting your voice go up and down and around and in and out with the movement of your hands.

Notice how your body responds to the changing intonation and pitch of your voice and to the spontaneous vowel sounds and consonants that are emerging. In certain esoteric Eastern traditions, different

sounds are believed (and experienced) to vibrate different parts of the body and in some Western medical traditions humming is considered a form of subtle massage. Notice, then, the effect on your emotions and body of the sounds that emerge. You are truly embodying the energetic pattern of the mandala, taking it back into the body from which it emerged, but this time with more conscious awareness of the original form that emerged from your creative unconscious.

drawing
painting

Draw a Mandala for a Big Dream

Now that you have basic ways to construct a mandala, you can enrich your experience of your big dreams by drawing a mandala as you contemplate their images, storyline, symbols, or feeling tone.

- Draw a containing circle.

- Divide your circle into four quarters.

- Draw a line gesture in one quarter, a gesture that expresses the energy or feeling you have when you contemplate a special aspect of the dream (What is the *feeling* of compassion? The *feeling* of overflowing love? The *feeling* of unalloyed freedom?).

- Repeat the mirror image of this gesture in the other three quarters, making a four-way mirror pattern.

- Alternatively, let the dream re-experience itself in conscious awareness while you doodle inside a containing circle.

- Color the enclosed spaces in the pattern in ways that please and inspire you.

Write a Short Dream as a Mandala

writing
drawing

Short, important dreams can actually be *written* in mandala form. The mandala provides a fresh way of "holding" and "containing" the energy of the dream.

- Take a short dream that feels important, even numinous (filled with an ineffable sense of deep import).

- Write it in a mandala form such as a single circle or concentric circles or four quarters within a circle.

- Use a different colored pen, pencil, or marker for each section, and color each section afterward.

Re-enact Dream Movements

movement

When many people tell their dreams, they cannot stop using their hands. They unintentionally mime—they relive and unconsciously embody each figure or entity through gesture. Wanting to show gestures or movements of a figure or entity—a waterfall, a falling rock—they begin to *embody* the energy of the dream, to allow it into physical consciousness. Our body is able to express what words cannot.

Miming bypasses noisy minds and directly taps into dream feelings and movements. It also allows access to unfamiliar ways of literal moving. Often, these ways are not part of our body's active vocabulary of movement during waking life. We usually don't swing back and forth slowly like an old oak tree or move like a waterfall. These are unfamiliar body gestures, and their wisdom can often stay unfamiliar to us unless we physically embody the symbol.

> "If a person doesn't believe in his dreams, he might say, 'It's only a dream, it's not real; the gods aren't really talking to me.' Little by little everything will become less clear...."
>
> —Huichol Shaman, in Harry T. Hunt, *The Multiplicity of Dreams*

When we free ourselves from words, we can experience the oak tree, the waterfall. When we do this, we need to quietly and nonjudgmentally observe our miming; embodying a dream entity can sometimes result in our becoming unhelpfully overidentified and we can lose our imaginative way.

Something inside us and out of awareness chooses the figures and entities that appear in our dreams. When we can let part of a dream character's behavior or gestures re-enact itself through our bodies, we bypass overactive intellects and have a larger intuitive picture. By miming the character's expression or behavior, we can more closely kinesthetically intuit what is moving/motivating the figure.

- Mime your dream self in a particular dream. If your dream self is lying down, lie down. If you are stroking a tree, mime stroking that tree. If you are running, run.

- After you have mimed your own movements, then mime the movements of *other* entities in the dream: the unknown person pursuing you, the tree creaking in the wind—feel its trunk being stroked by your dream self. Take each entity in turn.

- Now mime your entire dream. Put the whole sequence together. Re-enact it without words. Imagine you are communicating the dream to a friend who doesn't speak your native language.

- After you have mimed the dream in natural time, mime the dream again very, very slowly as though the film were running in slow motion.

- Close your eyes. Focus on the facial, hand, and body gestures that carry a special charge or interest. Repeat those gestures until they resemble a ritual dance. What do you feel in your body? What emotions fill you or play at the corners of consciousness? What spontaneous images intersect with the already vivid ones of the dream?

- As an alternative to miming the dream (which is sometimes socially or logistically impossible), close your eyes and re-enact the gestures of the dream in imagination. Find important gestures.

- After you have finished, briefly note responses or insights. It's quicker and closer to the nonlinear nature of dreaming to note them in ungrammatical form. Don't write them in sentences.

Kathy was a busy executive and longed for more balance in her life. She longed for a life partner. Kathy believed time and money were interrelated. She usually arrived at my office with a list so she could assure herself that she was maximizing the effectiveness of our sessions. She remembered few dreams, let alone one of the magnitude she brought in one morning. She wanted to excise it from consciousness as soon as possible. However, she was distressed by it:

The Ritual Death

I'm watching a ritual death. A man is condemned to die by his own hands. Two men stand behind him on guard. The man makes two vertical shallow incisions on each side of the heart. He doesn't close his eyes but looks a little below straight ahead. Then he takes two

steel pins and presses them through the incision points into the
two sides of his heart.

I know this will kill him because it will pierce the heart and stop
the blood flow through the chambers. I identify with his action so
strongly that I wake myself up crying out on a long breath.

Kathy usually relied heavily on her reasoning to make uneasy situa-
tions more immediately tolerable, and we had both agreed previously
that her intellect sometimes ran roughshod over her emotions during
verbal exercises. So we decided to work from another, less rational per-
spective. I asked her if she could either physically replicate or mime the
position of the man or whether she was willing to close her eyes and
imagine being in that posture. This would be difficult for her, but we
trusted our history together and her commitment to her inner develop-
ment. A private person, Kathy preferred to *imagine* herself miming this.
So she closed her eyes and sat quietly as she imagined herself miming I
sat quietly, imagining, too, how it might be to go through this ritual
and holding Kathy quietly in my awareness as she did her inner mim-
ing. When she opened her eyes, she told me about her experience and
later made these notes on it:

I imagined myself kneeling. I *felt* those two guards behind me—
but I realized suddenly that they were quiet and loving, not
fierce—there to help me do this thing, not to force me or punish
me. I imagined making those small incisions and didn't feel
much—they just went skin deep. They weren't painful—somehow
just a prelude.

Then I picked up the first steel pin and put it in. When I imag-
ined it piercing my heart, I really *felt* what this dream was about! I

understood it in my body! It was about my making sacrifices I need to make to let my heart be pierced by my own feelings again. Then I *wanted* to pick up the other pin so that I could pierce the other side!

I've been too shut down to let my connections with people go more than *skin deep!* I see now that won't change unless I sacrifice old beliefs and habits. I have to turn my warrior energy I have at work toward my own well-being. I need to make sacrifices—the perfect image, time, new projects. It's going to take courage to open my heart up! The courage I use at work. Now I'm going to use it to make time for my own heart—for relationship.

Through imagining this series of physical gestures, Kathy became aware of what she needed. We didn't have to analyze it; she could feel it in body and heart. She could feel the necessity of the sacrifices more keenly and quickly after this brief nonverbal experience than she would have after hours of articulate conversation.

Dream gestures and physical movements contain reservoirs of energy and wisdom if they are explored and lived out symbolically within a protected environment.

Move Like Your Dream Animal

movement

Just as we can work with dream figures and objects by miming their movements, so we can explore the movements of dream animals. They are most receptive to embodiment!

- Take five minutes to warm up your body and free up your movements from the censorship of your critical mind.

- Invite the spirit of the animal to enter into your body through the rhythmic intake of the breath.

- Use music or a nature tape to enhance the experience, if you wish. You don't need it, however. You can just listen to what your animal ears hear.

- With each breath, feel the body's shape and size change, the muscle masses reforming, strengthening, lengthening; the skin growing scales, hairs, fur; the eyes widening or becoming multifaceted, the ears growing larger, flatter, longer; the hands and feet changing into paws, claws, wings.

- Follow the change. Don't make it. Let your awareness follow a moment after the change. Explore your new size and shape and gravitational relationship to earth and sky.

- Take your time. Explore slowly. Let your animal form do the things it might do during the day or night. Imagine soaring, crawling, pouncing, creeping, sliding, devouring, diving, hovering.

- Let sounds come. Don't attempt to sound exactly like the animal. You are not a perfect mimic; just express its spirit. Let yourself laugh if an odd sound comes out. The spirit of sacred improvisation almost always involves both gravity and humor. Take your experiment seriously, but don't take yourself too seriously.

- Stop before you get tired. Set a time limit on the exercise. It's sometimes easy to enter into a slightly altered state but to be inattentive and careless (for ourselves as well as others) about leaving that state.

- Allow time to re-enter your human body just as attentively and patiently as you entered the essence of the animal.

- Draw, make notes, or dictate your experience. What feels unforgettable at the time is often lost in the press of getting the brakes fixed, the child to the game. These activities are as important as dream work and need completion with attention and awareness. There are no hierarchies of experience, just repeated opportunities to bring loving attention to each one.

Tell Your Dream from a New Viewpoint

dramatization

Dreams encourage us to have a different perspective—sometimes many. Several dream theorists (including Jung and Perls) postulate that dreams use familiar or unfamiliar players from our lives to play roles with which we are less familiar than the role we, ourselves, play in the dream. While Perls' Gestalt approach suggests we *become* the glass of water we drink in a dream, Hillman has reservations about this, believing there is a reason we are in a certain position in the dream, that becoming the glass of water is not as helpful as exploring the experience of drinking.

While there are drawbacks to playing out other dream roles, it can also be helpful if we don't take it to melodramatic or overidentified extremes. If becoming an element in the dream lightens our burdens in a substantial, coherent way and helps us move in our inner or outer lives with more independence, mutuality, clarity, acceptance, energy, ethicality, and grace, we are using the practice well. If acting out every part of a dream just provides for a florid show without integration of the drama, it is a waste of our psychic and emotional energy.

Let's look at Paul's dream. In its conflictual stance, it seems to indicate that part of Paul is opposing his own well-being.

Confict!

I am training in the Army with a partner. We each have guns. I forget my move and say so without embarrassment. The instructor ridicules me. He demands to know when and where I was born and says scornfully I must have been rejected really early. I'm livid. I tell him he has no right to say this and walk out. The instructor collapses and starts crying to get attention from the class who help him into bed. He's not used to being confronted. I know this incident will be a problem for me in the course, not only with him but other instructors. But I don't care.

Paul was encountering opposition at work. He sensed the dream had more to say than just that he felt beleaguered by his boss and needed to stand up to him. In fact, he was doing a fine job of negotiating a difficult situation. Paul decided to tell the dream from the viewpoint of the instructor.

I've been an instructor a lot of years. I've got a new bunch of trainees. One's a bit slow—makes bad mistakes but doesn't seem to care. I like the guy but he's going to blow it now we're training with guns. He could kill someone! I blast him out of the water to teach him a lesson he won't forget. But he just gets angry—acts superior. I'm so angry I get a heart attack and have to be helped into bed by the trainees. I'm frightened—humiliated.

As Paul retold the dream as the instructor, what became clear to him was that he had to come to terms with two parts of himself: one that was careless and superior and one that was wise but rough. He had an internal monitor who was more like a tough instructor than a kindly coach. He realized that if he could tone down his internal instructor's ways of talking to him, his careless side might learn something. He also realized his anger at himself was similar to the wrath he experienced from his impatient father, a loving but unbending disciplinarian.

Paul saw that he was right to defend himself but that he needed to negotiate with this inner instructor. He also realized he was afraid his pattern of underperformance followed by overwork could put his health at risk. His imagination created a heart attack in the second version: Paul had male relatives who had died early of heart disease. This dream led to long-term behavioral change for Paul and also internal renegotiations with his rebellion and idealism.

What about the other possibilities? What if this dream were not about this issue? Wrong questions. There *is* no right interpretation. Right questions: Did Paul nourish the dream? And did he find a way to let it nudge him along?

Retelling from another character's viewpoint, particularly if that character is anathema to us, can bring unexpected gifts. Often, an unfamiliar character metaphorically encapsulates sealed-off energy we need to either express or rein in. Personifying these energies in dream figures provides entry points into that never-ending cycle of bringing ourselves home to ourselves.

> That matrix which makes the dreams in us has been called an inner spiritual guide, an inner center of the psyche.
>
> —Marie-Louise von Franz, in Fraser Boa, *The Way of the Dream*

dramatization

Converse with Dream Entities

It's a sign of a rich encounter with dream figures when what they do or say surprises us. Jungian theory suggests it can be even more surprising and fruitful if we allow the dream to dream itself onward in waking life by our engaging in active conversation with the dream entity. By keeping our controlling mind out of the picture, we can engage consciously with our creative unconscious. This form of dialogue differs from others where only one imaginary figure is speaking. In this practice, your ordinary ethical waking self engages with a dream entity, allowing the dream to move onward into another scene that might or might not be related to the original dream. Anna, for example, recently had this dream:

Shy Mountain Lions

I am staying at a resort with an old friend. We wake and are supposed to go down for breakfast. My friend says we can't because there's a storm coming. I look out the window. The sky's really blue—no sign of a storm—but I see two shadows. They look like wild animals. I yell at C. to hide because I know they are going to come in. We hide under the beds. My heart's pounding. Then I see this huge paw beside the bed. I lift the bedspread a bit and suddenly I am eye to eye with a lion. Another one—it looks old—is standing beside it. I'm just about to talk to them when my alarm goes off.

When Anna held an inner conversation with these fellows, she followed Jung's suggestions for active imagination. She grew quiet, closed

her eyes, and re-entered the dream. When she could see the lions, she asked them questions. Anna stayed herself—her ordinary, waking personality. She didn't let them persuade her to do anything she wouldn't do in waking life. She didn't give up her own personality. If she didn't understand something, she told them; if she didn't want to do what they asked, she said so. Here is part of what she wrote:

> I went back to the part in the dream where I was looking in the first lion's eyes. We stared at each other. I thought nothing was going to happen and I might as well give up. Then suddenly he winked! I thought this was too silly. It must have blinked. I looked and it winked again!
>
> ANNA: Can I trust you not to hurt me if I come out?
>
> LION: Do I look like someone who'd hurt you?
>
> ANNA: How about your friend? (I pointed to the tufty one.)
>
> LION: Her? She's deaf and old and just wants milk. (I got her some. She slurped it up while I talked to the first one.)
>
> ANNA: What's your name?
>
> LION: Nothing you don't know.
>
> ANNA: What's THAT supposed to mean?! (I was getting impatient.)
>
> LION: Well, (in the voice of a patient teacher) if you can't remember, I suppose I have to tell you *again!* Braveheart.
>
> ANNA: *Are* you brave?
>
> LION: I'm the part of you that's courageous when you take risks with your feelings. I thump and thump my tail (you think it's your

heart) when I'm scared. But I go ahead anyway. I've come to tell you something.

ANNA: What?

LION: Stop putting me on that damned leash when you go off in the mornings! I'm tired of sitting around all day snoozing. I want to go with you when you work and meet people. I'm bored and I'm insulted. And I'm getting bad tempered from being cooped up!

ANNA: People will be terrified if I take you with me! They'll take one look at you and run screaming in the other direction!

(The lion sighed and looked at the old lion licking the milk.)

LION: You're so literal! Do you think I'd be dumb enough to turn up looking like this?! I can get smaller or larger without losing my strength. You even can put me in a place inside your body where I can see everything but not be seen unless you want me to come out. Then I can get as big or as small as you need. OK?

ANNA: Well . . . (I felt dubious.) I'll try it. By the way, who's your friend? Another part of me I'm supposed to know?

LION: Too soon for you to talk to her. (He said this breezily.) You'll need her after you get used to walking around with me.

(He seemed to fade and I was thirsty. So I poured myself—yes—milk!)

Anna continued to work imaginatively with these lions. They taught her about her fear of taking risks, about her need to stay on her own side when she had close connections with others. These two figures became like totems for Anna.

This kind of dialogue can be used with different kinds of dream entities but most frequently with figures and animals who appear to be unfamiliar to us and whose role in our inner lives is one that we would like to appreciate more.

Use a Stone to Mark a Sacred Dream

Our ancestors carved and painted images and symbols of their dreaming and waking lives in caves and on rocks. Some of these survived the ravages of time and the waxing and waning of individual lives. They remain silent, eloquent, mysterious testimonials to the lived experience of inner and outer lives and to the universal desire to record experience in image, ritual, and tale.

Stone Messages. When I visited Uluru (Ayer's Rock) in Central Australia, we walked around part of its huge perimeter (several miles) and looked up at the pictographs on the blood-red overhangs and caves, shimmering in midday heat. There were pictographs of hands and figures, of images I did not understand. At sunset, I silently watched Uluru turn into flames.

Stone Messages. Under a similar shimmering sun, a friend from a Pueblo Indian village took me to visit ancestral pictographs and petroglyphs. The symbols and figures reached across generations on this silent, cloudless New Mexico day, reached across my cultural ignorance. I did not understand them but I felt their import. I wanted to touch

> Both dreams and the ritual arts manifest and mediate transpersonal energies. Both are forms of enactment expressing the depths of existence and the energies flowing from the source through life.... To use processes suggested by one to illuminate the other may permit us to relate to the dream in terms that do not lurch it from its matrix, yet facilitate and develop participant witnessing in the dreamer.
>
> —Sylvia Brinton Perera, "Dream Design," in Nathan Schwartz-Salant and Murray Stein, eds., *Dreams in Analysis*

ritual

them, to feel what my friend's ancestors felt as they worked on these stones.

Stone Messages. On a chill midsummer day in Norway, we crossed the highest pass—a plantless landscape shrouded in severe folds of snow, broken only at the lake's edge stained peacock blue by submerged ice. In this barrenness, there was one sign of life: cairns of stone. Climbers leave cairns to mark their passage, to leave a message for others.

Stone Messages. Carl Jung, at a difficult time in his own inner journey into unknown territory, stayed by the Zurichsee and, from the lake's edge, gathered stones with which to build. He also carved symbols and words into stone. He spent a long time building and carving. It renewed him so he could travel further into the realm of the individual and collective psyche. A quietness comes when one walks around this part of Jung's home, a respect for the courage, despair, trust, patience, love, and faith that must have gone into those stones.

We, too, can mark our passage through new lands. We can record wisdom from the land of dreams on our own stones. Not every dream. Not every piece of wisdom. But the Life Dreams, the Big Dreams. We can gather stones from beach, hill, valley—smooth stones to write on. We can even go to a gardening store and choose smooth, large, river pebbles, keeping the stones small enough to be able to carry but large enough on which to write or paint a few words or a symbol.

We can buy paint—perhaps earth-colored paint—that will survive rough weather. And we can paint our dream symbols on the stones to remind us of the Dream Snake, the Dream Spirit Guide, the Dream Voice on the Wind. We can record their wisdom in word, symbol, or simple line image and place each stone on a small cairn in our garden or

special place—perhaps even in a tray of sand we smooth and design like a Zen garden.

At some Japanese shrines, often tucked away in a small, shaded, forested corner of the garden, visitors come upon *Jizo,* a small, tubby stone figure with the hint of a face. It is the guardian spirit of children whose lives ended early. Their parents ladle water from the pool beneath the figures over their heads. The stone gods grow mossy hair on their oval heads. The ongoing care for and love of the child and the statue seem embodied in this silent, single gesture of ladling water over stone.

If you wish, keep a wooden ladle and container for spring water. Occasionally pour water over your dream stones. It will remind you that wisdom—both joyful and painful—is not only eternal but must be remembered and allowed to flow in the waters of our daily lives as well.

Use Collage to Express Color, Shape, and Theme

collage

Dream images open to transformation through the quiet invitations and firmer demands of the collage process. Collage is an assertive medium. It influences us as much as we influence it, particularly when we make a dream collage. Collage comes already half-made. It meets the maker halfway across the bridge of creativity, bearing colors, forms, and texture that we only need to shape and combine. This can be freeing and helpful when we have less time and even less creativity.

Elements of Collage

Two-dimensional collage plays with five basic factors—color, shape, theme/content, texture, and composition. The first three are most relevant to dream art. As dream workers, most of us don't have the time or

luxury of making images accurate. There's no advantage in making a collage piece that "looks like" your dream. Rather, let the different elements of the dream play out impressionistically through collage.

Color

Colors and shapes carry feeling, and their relationships to each other carry the relationships between the feelings However, the traditional associations do not necessarily reflect the feeling you might have about a color in a dream. Black can feel mysterious in one dream, depressive in another, full of depth and the night sky in another, and a reminder of a friend's skin tone in another. Some dreams are drenched with colors. Others are drenched with feelings. Find an image that evokes rather than represents. Let it infuse your body with its feeling tone.

Shape

The mood of the dream determines the shapes you cut or tear. (So does the time you have available.) Complicated shapes take time. Jagged edges evoke jagged feelings; ragged edges, ragged feelings; rounded edges, smoother feelings; square edges, orderly feelings. Don't plan shapes. Let the scissors be an extension of your hand, which is an extension of your arm, which is an extension of your body—which is the container of the dream. You can feel this uninterrupted flow easily if you keep the feeling of the dream in the body and in the breath. Sometimes, you won't want to use scissors. They can feel too removed from the energy of the dream as it spreads through the body. At other times, you can appreciate the graceful skill of scissors.

Shapes often work themselves into dream collages in two ways. A

shape in the dream itself—the oblong swimming pool, the square room, the spiral staircase, the broken glass—can appear in the shape of the collage pieces. Often you won't even realize until you begin the collage that there is a repeated shape in the dream. Just let the shape appear. Reflect on possible indications later.

Shapes also work themselves into the collage through feelings. If you want to express a formal mood in a dream, you might find yourself cutting long, rectangular shapes and placing them vertically on the page. If you are in a peaceful mood, you might find yourself using undulating shapes and placing them horizontally. If you have a dream chaotic in content and mood, many shapes might appear, some only partially realized. Don't plan; follow. Reflect only in retrospect on your patterns. A torn piece of paper can express an image well if you let your imagination flow.

If you are fascinated by the visual characteristics of a dream animal or familiar entity, use photocopies of the entity. When you photocopy pictures, use the highest quality copier available so that gray areas show. Make four copies of each image so you can play with cutting up images and making patterns. If you can afford it, make color copies.

Composition

Let yourself make either a free-form collage, where you place the pieces purely according to where hand and eye put them (use rubber cement so that you can move them later if you wish). Or you can make a more formal, ritual collage that forms patterns—a mandala form, a circle (with or without "pie piece" divisions), a spiral, a mobile, a square, a Styrofoam ball covered in images, a cardboard box covered in images outside, inside, or both. Don't analyze why you include certain images

or why you place them where you do. Attend to your intuition and feeling for selection and placement. Notice your body's response once you have selected and placed them. Surprise yourself.

After you have finished the collage, spend time contemplating it and writing about your experience. Quietly observe anything about its texture and composition.

When you consider texture, ask yourself:

- Are the edges smooth or torn? Are they a combination? How does this smooth/torn texture of the collage affect me? Does it enhance my experience of the dream in some unexpected way?

- Have I included differently textured pieces? If I were to describe those textures, what adjectives would I use? How do these adjectives reflect my inner state at present in relation to this dream or my life in general?

When you consider composition, ask yourself:

- Do my collage pieces each have their own space or do they overlap?

- Which pieces are closely connected to others literally or visually? What do I associate to those connections?

- Have I overlapped the edges of the board or paper on which I made the collage or was it important for me to stay within the edges of the paper? What is my reaction to that intuitive choice now?

- Is there a particular collage piece around which all the others seem to fall into place. What is its shape and color? What draws

me about this piece? Are its shape and color and dominance metaphors for something about the dream or me?

- Can I see an overall, unifying principle to the collage? What adjectives would I use to describe that principle, for example, circular, spiral, jagged, bilateral, dark, elegant, heavy, undulating, spacious...? Do those adjectives reflect my inner state in some way?

- To where does my eye return in this collage? What associations do I have to this place?

Contemplate your collage. After you have considered questions that intrigue you, place your collage just below eye level and meditate on it with unblinking eyes for as long as is safe and possible. Doing this allows you to re-absorb the color, feeling, and shape into body and memory in a way that allows them to evolve silently and invisibly toward the next image.

Dreams Following Collages

Pay attention to the dream you have the night after making the collage and see what commentary your unconscious might have on your experience. Notice whether colors, shapes, themes, or textures that revealed themselves through your collage reappear or evolve. Each art nourishes the other and your collage will have nourished your dream life in unexpected ways.

Collaging Beyond the Dream

Sometimes, a collage that begins with a dream image takes a direction of its own, departing from the original. This is a wonderful experience,

not something to be controlled. You are giving expression to your dream in order to pay homage to it, nourish it, and allow the images and symbols to evolve, not preserve the dream! You are not doing this for a class but for your soul.

Make Masks of Dream Figures

Maskmaking has as ancient and honorable history in many cultures' spiritual and psychological development as pictographs and petroglyphs. It is a universal, cross-cultural practice. This experience of making a mask usually takes on as powerful a sacred, meditative quality as the experience of wearing it.

maskmaking

To make a mask of your own face as it appears in a dream or to make a mask of another figure or animal is to deepen your connection to that figure significantly. This kind of maskmaking resembles the energy translation practice. *You do not have to know how to draw a face in order to make such a mask.* You are presenting the essential energy of the figure or animal; you are not *representing* the actual figure or animal. To wear such a mask is to tap into the archetypal patterns and sources of that figure. Approach this work with respect, containment, and privacy. Let's take a short dream that Leo explored through maskmaking:

Where the Sun and the Moon Are One

I dream that I am wading out in the lake. I look up into the sky and see the sun shining brightly. I swim a bit. Then I look up and it's the moon looking down. I look at the reflection of the light in the water and can't tell whether it's sun or moonlight but it seems to be both somehow. I'm really intrigued by this and can feel this

odd, hot-cool light on my body and face when I stand up in the water.

Let's review the guidelines that Leo followed and note how he applied them.

- Listen to music that helps you grow quiet—drum music, ocean music, bird calls, classical music—whatever focuses energy and lowers self-consciousness and self-criticism.

- Take a heavy sheet of white or colored paper that absorbs water-based poster or acrylic paints without wrinkling or dissolving.

- Cut or tear the paper into a simple shape that represents the shape of the figure's face. If you are confused about how to do this, think about what geometric forms the figure's face resembles *in your imagination.*

- Cut out places for eyes. Don't worry about the *actual* shape of the eyes. If they *feel* big to you, make them big; if they *feel* almond shaped, make them that.

- Do you want the figure's mouth or beak to be open or closed? Don't think about it; look at the inner image of the figure or feel it standing in front of you. Ask yourself, "Is the mouth open or closed?" You'll know. If it's open, cut out a hole for the mouth.

- Don't plan how you are going to paint or collage the mask. Focus on the spirit of the figure. If it was quiet, you might choose restful colors. Let the spirit of the figure move through your arms and into the colors, pieces of glitter, torn collage images, or other elements you paint or glue on the surface.

- Let your body and the mask's spirit tell you when you have finished. Don't assess this by artistic criteria; these only obstruct.

- When you have finished, title the mask on the back, date it, and write down the words that first occur to you when you look at this image.

- Now hold up the mask and look in the mirror.

- Have a trusted friend or dream group member take a photograph of you wearing the mask. Sit quietly with the photo and allow it to speak to you. Write down carefully what it says (and don't take it literally).

Leo wanted the right half of the mask with the moon-eye to be blue and the left half with the sun-eye, bright yellow. He used poster paint to color each side. He found himself drawing curly clouds on the moon side—on the figure's cheek—with marking pens. On the sun side, he found himself using different crayons to draw simple flowers and a tree. He titled his mask, "Sun-Moon Spirit," and wrote, "cool, watery, calm, woman, my better half, something I'm afraid of, watches over me" on the back of the moon side. Then he wrote, "fiery, angry, out there, growth, enlightenment, strong" on the back of the sun side. Right in the middle, he suddenly wrote, "peace." Later, he sat down with the mask (which he had hung beside his computer in the family room)—and let it speak to him. It began like this:

> I'm where you're headed. No more division. No more "either-or" stuff. I'm you all put together with all the bits operating at once. You need me—not just my pieces but the whole me. Keep looking at that place where the blue and the yellow meet. They make green. There's growth there in bringing us together.

Like omens and oracles, masks rarely bother about the daily exigencies of life. Occasionally, they offer practical wisdom (slow down; be more attentive; open your heart; sleep more). Simmer advice or wisdom offered to you by inner figures in the pot of everyday living for a while before you eat it. Masks are concerned with impersonal energies, with archetypal energies, both bright and dark, and their messages need to filter into our lesser consciousness slowly so that we can tolerate and absorb their greater scope.

Use Clay to Express Feeling, Movement, and Figure

clay

The first time I worked with clay, my heart caught its breath and soared. I found myself making love with space, with the unknown. In every second, I saw my unconscious express itself through a different hand movement, through an unrepeatable gesture. The clay started to direct me, to take charge of the dance, to capture my attention, to teach me receptivity, to evade my control. It taught me to be messy, sensual, and childlike; to sacrifice one idea for another; to have courage to occupy physical space with my visions.

Friends who are potters in Pueblo Indian villages in New Mexico had told me about the spirit of the clay, about their needing to attend to its desires. I stopped "working" the clay and started being led. In the space between two moments, the clay started breathing me. It was clear about what it wanted, although my lack of expertise often redirected its movements. My awareness was suspended between breath, body, and clay; my hands moved in response to its subtle direction.

Clay is one of the most responsive media for dreams. It takes longer than other practices. However, it will richly repay you. Keep malleable,

cheap clay available. Keep it cut (with string) into pieces about six-by-six-by-two inches—easily carried and usable. Because clay depends on water for life, keep the plastic bag sealed so that it doesn't harden. Keep a few "tools" handy—old kitchen utensils.

- *Warm up.* When you are ready to explore a dream with clay, warm up with slow, full body movement, sometimes accompanied by contemplative (but not sentimental) music. Some days, you won't like music; you will feel too receptive to the mood changes it creates. At those times, listen to trees or birds or your breath.

- *Work with your breath.* Rhythmically align each body movement with your in-breath and out-breath. Let the breath decide how it wants to move your body. Let your body follow. When you have truly given up directing the movement, you can notice that awareness of where your body is moving follows a split second after the body has moved. Unless you are in a large, protected space or have a friend around to protect you from falling, keep your eyes half-open.

- When your body is rhythmically and easily responding to your breath, move quietly to where you have two pieces of clay laid out on newspaper and plastic: one, about the size you can grab with one hand; the other, about three times that size. Work the clay with the whole body, not just the hands. Move around all sides. Make whatever position you are working in easy on your back and neck.

- *Breathe into the clay.* Close your eyes. Place your hands on the clay—both hands—and invoke the dream. Breathe in, and then breathe out. Allow each in-breath to fill your body with the

dream's images and energy. Then, breathe *out* the dream experience into the clay by making a *single,* two-handed movement. You might find your hands twisting, pummeling, squeezing, or bisecting. Whatever body and hands decide to do, put your whole breath into that single movement. If you want to make a clay piece for an important figure or animal, first tell yourself that this is a reminder, not a replica. Express its nonrepresentational essence. Express the *quality* it embodies or evokes. Perhaps imagine you are making a secret symbol that stands for the dream figure's life force.

- *Contemplate the form.* Open your eyes and look at the small piece. Turn it around until you find a part that surprises or intrigues you. Whether it looks like something in the dream or not is unimportant because your focus is only on which shape holds your visual or emotional attention.

- *Build on the form using breath.* Using the larger piece you have set aside, begin to build a larger response to the section that draws you. Don't replicate the smaller piece. Use it as an imaginal departure point for the larger. Hold the dream in your imagination and body as you form the piece, even though, at this point, the shape it is taking has no logical connection with the dream. The logic has shifted to the kinesthetic realm and few of us are skilled at translating that into verbal, linear explanation. Keep holding that dream image and continually breathe it into the clay as you let this larger piece build and change itself. Just as the breath enters and leaves, creating a place for the fresh breath to enter in, let the clay form and reform itself, each time letting go of old shapes to make a place for new. Let go of all expectations except the constancy of the dream image.

- *Let the clay dream on.* Sometimes even the dream image itself changes, dreams itself onward. Don't resist. Welcome it as you welcome new breath and new shapes. You have been receptive to the dream image; now it is free to reveal more of itself. You probably won't want to use music here. The dream carries its own silent music, and your breath can be the rhythm that accompanies the syncopated slaps and thuds of the clay as it moves your hands.

- *Stay in your body.* Keep your muscles flexible and loose. It's easy to become so absorbed into the flow of the image, the breath, and the clay, that the body can slip out of awareness until something begins to hurt. There is no need to pay for a clay session with discomfort. Keep your whole body present, actively receptive to the image and to the feelings breathed out. Stretch. Stand. Move from one side of the clay to the other. Walk around the house or garden. Shake your body out in the kitchen.

Clay allows us to dwell with dream images at a non-rational level, at an embodied level, at a meditative level, so that they feed the soul. Clay allows us to pay homage to the forms that appear in and for the soul.

Expressive Dream Work
with Nightmares

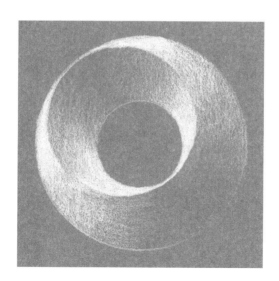

"[Dreams] have a superior intelligence in them . . . which leads us. They show us where we are wrong; they show us where we are unadapted; they warn us about danger; they predict some future events; they hint at the deeper meaning of our life, and they convey to us illuminating insights."

—Marie-Louise von Franz, in Fraser Boa,
The Way of the Dream

Bad dreams. We awake with the memory of the tooth pulled without anesthetic, our children dying in a fire we inadvertently set, the monster child born to us, the ax murderer in the unlighted house. We want to escape the image. The last thing we want is to explore the dream creatively! We turn our own images into scapegoats, boo them out of town, lock them up in forgetfulness, or run fleeing from them into the safe haven of waking reality and ordinariness.

Yet dream events are neither good nor bad. One of my meditation teachers once declared, "It is better to be good than bad but it is even

voice
writing

better to be neither." We need to look at both sides of anything and anyone if we are to accept the wholeness of events and people. Jungian analyst June Matthews comments, "Hell is part of the Self, too." Moreover, horrific events are not necessarily horrific from the soul's point of view. The soul has a different, timeless perspective on life.

Hindus perceive three aspects of divinity, each necessary for the inner and outer cycles of life to continue: creation, sustenance, and destruction. The gods and goddesses of destruction get bad press, but they do good work. They dissolve obstacles. They destroy the old to make a place for the new.

If I think about my nightmares in this way, my perspective changes. Some bad dreams cloud awareness, sear the ground of waking consciousness, burn out my ancient, cherished belief structures, and ravage my sense of who I am. At those moments, it's hard to remember that, in my inner world, grass will sprout again, birds return, trees green out. But I keep learning (again and again and with patient reminders) that nighttime or daytime journeys to hell are, indeed, part of my Self's way of renewing itself.

"Bad" dreams can balance out idealized versions of ourselves, others, events, and values. They can bring form to the dark side of an event, a side that is always present if we remember the longer wavelength of the notes of eternal time. Some dreams scream real warning, danger. Others exaggerate, finally getting through to us like friends shouting, "Fire!" in a burning building. Some dreams bring up past experiences that need to be set to rest in heart and memory. These, too, are constructive: they alert us to places within us that are still quietly bleeding, places that need healing through forgiveness of ourselves or others, places that need new perspectives. Some nightmares warn of actual

approaching dangers; others warn of subtle patterns of ill health being laid down in body or spirit; unfortunately, few of us grow skilled enough to know which dreams are prophetic until after the event. And some "bad dreams" are probably just due to bad cheese....

> It rarely happens that [dreams are] either exclusively positive or exclusively negative.
>
> —C. G. Jung, *Collected Works*

On rare occasions, children are born without the capacity to feel pain. They are at high risk. If they cannot feel pain, they have no idea when they are hurt. We need the wisdom of our fine-tuned pain receptors in body and psyche. Nightmares are often accurate pain receptors.

Look at Both Good and Bad Associations to Images

imagination
wordplay

Andrea, a lawyer with solid, healthy relationships in her inner and outer life, awoke screaming from a nightmare and could not fathom how she might work creatively with its content, its affect, or any message.

I Accidentally Give Myself AIDS!

I'm on an expedition to clean up the environment. We've made a pledge to pick up garbage. I pick up some papers and what I thought was a straw but it's a hypodermic needle that accidentally punctures my lip. I'm sure it is infected with AIDS. I'm horrified. I should have been wearing gloves. I start to walk home. I know I'm probably going to die a long, slow death and there's nothing I can do. I wonder how I'm going to tell my husband I was stupid enough not to wear gloves. I know I can't even get tested right away so I have to live with not knowing if I'm dying. I wake up sobbing.

Not a cheerful dream for a Monday morning. Had Andrea been feeling in bad shape, we would have worked differently with this dream. But she was in good inner and outer form (at least, as good a form as most of us ever get in). What creative possibilities could she find here? We didn't want to "do a Pollyanna" on the dream, to dull it into spiritual safety, or to lull our shocked senses into saying, "That wasn't horrible; that was a wonderful learning experience." It was, indeed, a horrible internal experience. Nor did we want to jump into interpretation, although we were both open to insights that might spontaneously emerge from walking around the dream.

Andrea amplified her associations to AIDS. They were all bad. I asked her if she could draw on any good associations. To her surprise, she found one:

> Someone was talking with me recently about how rewarding it is to work with her AIDS clients. She said that many feel close to God. They have a clear sense of what's important and what's not worth worrying about. She said many were committed to living fully despite their worst fears being realized.

Andrea and I wondered together what it might be like for her to let old parts of her die yet enhance her spirituality and perspective on life. Andrea retold the dream to herself using this perspective:

> I'm cleaning up messy bits of my life (the environment) and in doing so, get hurt by something (the needle) that might cost me my current way of life. If I can get past the fear and the self-recrimination for having gotten myself into messes in the past (not wearing gloves), maybe I could focus on what's really important to me.

Here are ways to use Andrea's approach with your own nightmare:

- Make word webs (see chapter 3) of your negative associations to images or events or entities in your nightmare.

- Now make word webs of positive associations for the same images, events, and entities. For example, a knife that kills in the dream might seem negative, but not all knives and their uses are negative. A grotesque figure that is pursuing you might seem only negative at first—but isn't that same figure powerful, in control, directed?

- Review the positive associations. Where might you be misinterpreting the presence of these positive qualities in your waking life?

When we make word webs to note our associations to both the light and dark sides of all images in nightmares, we glimpse possibilities for our hearts other than fright and misery.

Find the Opposite Image for Your Nightmare

imagination
wordplay

Let's take Andrea's dream (from the previous practice) and work with it differently. Andrea and I imagine the nightmare is sent to her by a Wise Godmother who knows how to get her attention. The Wise Godmother sees around corners, sees in the dark. We imagine the Wise Godmother speaks in riddles; she uses a dream as a trick mirror that reverses and corrects for the beliefs we live by during the day. Andrea now describes the dream's opposite:

Nightmare Opposite

The dream would portray a world in which nothing bad, unex-
pected, or unfair ever happens, I am never at risk, never have to be
attentive to my welfare. I'm always rewarded for good deeds. . . .
That sounds pretty childlike. I'm walking around in a sophisti-
cated, political, and social world with my childlike trust wide
open! I still, at heart, expect everything to turn out right if I'm a
good girl! I guess it's taking the exaggeration of this nightmare to
point out to me how impossibly idealistic my ideas of goodness
and justice are!

As Andrea looked at this reversal, she commented that her trusting
nature was not always discerning. While she understood that dreams
often exaggerate to get their point across, Andrea also knew this dream
was not to be ignored or diminished. She needed to pay attention to
where misplaced trust might be endangering her.

Like Andrea, we, too, can attend to the constructive function of our
nightmares and dance with their skeletons until their wise energy is
brought to life.

- Take each image in your nightmare and note down its opposite
 or what might constitute an opposite; for example, a threatening
 figure would become a helpful figure; a knife might become a
 healing wand, a dark night could become a sunny day; a scream
 might become a song.

- String this series of opposites together into a narrative that fol-
 lows the original.

- Ask yourself where this narrative resonates with any of your beliefs, experiences, and attitudes in waking life.

- Consider whether these beliefs, experiences, and attitudes might be skewed too strongly in the direction of the positive or denial of the dark in your waking life. For example, if you dream of your new beloved as an ax murderer, this doesn't mean either that she is or that you are terrible for dreaming this. It might mean that you are only thinking of her as perfect, and your unconscious is working overtime by giving you this dream to remind you that she is very human and needs to be seen and accepted for all she is (warts and all), not just for your idealized view.

> "Nightmares are substantial, vitally important dreams. They wake us up with a cry.... Nature ...wants to shock us out of a deep, unconscious sleepiness about some dangerous situation."
>
> —Marie-Louise von Franz, in Fraser Boa, *The Way of the Dream*

Contain a Nightmare in a Short Poem

Nightmares overwhelm us. They bleed into every part of life and temporarily disarm our personalities with foreign, untamed energy. We need to contain its effect if we are to perceive the nightmare without too many defenses but with enough to enable us to receive its message. Containing the terrifying image within a fixed form can restore perspective and proportion.

writing

- Write out your nightmare quickly, without attending to punctuation or spelling. Finding the *essential* words helps contain the dark images.

- Now, using only about half of the words and *only in the order in*

which they already appear, build a five- to eight-line, free-form poem with them.

The poetic form respects and contains the intuitive, nonlinear structure of the wild, overwhelming affect of the nightmare. The intensity of a poem respects the enormity of the affect while corralling its images; the density of a poem gathers in the runaway energies that threaten to stampede consciousness. Here is Stuart's nightmare. Its original form was just the words without underlining. The underlining helped him choose the words essential to capture this terrifying scene.

Tamed Bear Kills

There's a bear—a very large bear. It's been befriended and tamed and lives across the street in a pretty house. But things go wrong. A baby starts to cry. It races over to protect the child but when it starts to pick it up, it mauls the child with its claws and the child emits a piercing scream. We rush to protect the child, getting the bear off. The bear loses a paw with claws. It falls through the floorboards. We see we have created a monster by befriending it. Then we see someone else killed or someone tries to kill the bear. Shots ring out and someone is killed. We race over.

Using the essential words, Stuart put each image or feeling down on a separate line:

The Bear and the Child

Befriended,
the large bear lives

in a pretty house
across my street.
Things go wrong.
A child cries.
The bear tries to protect her
but mauls.
A child's piercing scream.
We rush
to get the bear away.
He loses a paw.
Claws fall through the floor.
Shots ring out.
Someone, perhaps the bear,
is killed.
We have made a monster
by befriending it.

After Stuart wrote the nightmare as this poem, he noticed subtle shifts. Because each image was on a separate line, he could take in one at a time. This let him be more receptive to each image, to see each discretely yet without severing it from the whole in which it was inextricably located.

The poetic form also allowed Stuart to see each image as not only personal and specific but also archetypal and universal. A larger process was being portrayed here. It did portray aspects of Stuart's development, but it also portrayed larger truths about maintaining a healthy

respect for the wild part of all nature, especially our own wild sides. Stuart had been reining in parts of himself that seemed to overwhelm others. After this dream, he realized he needed to distinguish his fierceness when it was hurting him by being overprotective from his fierceness when it was appropriate. He realized he would always have a wild and fierce part, no matter how he tried to domesticate it. However, he could begin to channel it into more appropriate contexts where it could wander undisturbed.

drawing
painting

Create Contained Energy Paintings

Mixing strong energies from the realm of the dark gods with the human energies and needs of the day is challenging and demanding on our psyche. When you are working with nightmares (or images whose charge feels almost too much to handle), it's wise to approach energy paintings slightly differently.

- *Set a time and a time limit.* Energy paintings are usually best done on waking. Avoid doing energy paintings of nightmares before sleeping. They usually raise adrenaline, and bedtime is for relaxing. Do it quickly, within a time limit (ten minutes at most).

- *Allow recovery time.* Don't do one just before have a stressful situation to handle. Choose a time when you can schedule a nonstressful event such as exercise following it. Do something repetitive and easy—do a load of washing, walk the dog, weed, pay the bills.

- *Choose your paper carefully.* Choose paper that seems too big to fill. If you don't have big pieces, use newspaper or tape pieces of newsprint together, or choose a piece of paper that is tiny—

three-by-five inches feels right for many. If you want an idea of how "big" a tiny painting can be, look at Alice Miller's *Pictures of a Childhood*. They are big painful images each done on postcard-sized paper.

- *Make a container.* Once you've chosen your paper size, draw a visual container for the dream on the page. Usually, a thick, strongly colored frame suffices. If this doesn't seem strong enough, draw something that would be—a metal safe, a thick pot, a bottle, a box.

- *Monitor yourself while doing the translation.* Paint within the container. As you are painting, if you feel the container is not strong enough to hold the energy of the image, reinforce the boundary.

- *If you feel too much energy building up, jump up and down and bellow.* If you can't do this because your house companions or neighbors might throttle you for disturbing the peace, walk briskly around the block swinging your arms and then return to the painting.

- When you finish, name it, date it, breathe deeply, then go off, and forget it. Don't even think about it. There's no virtue in working on the dream any more that day. You have listened well to it. Allow it to be quietly reabsorbed into your psyche.

Make a Healing Mandala

Sometimes you don't feel like working on last night's nightmare. It's tax season, you have a cold, you owe letters and calls, you need to spend time with a family member—and you don't want to look at the bad dream that deprived you (and possibly another) of an extra hour's sleep.

drawing
painting

But the nightmare won't blow away. It hangs in the air like the smell of cooking oil in a small restaurant. It hangs in your hair, nose, and clothes and subtly flavors your day (often to others' detriment).

Give in. Do a mandala. Color in books of predrawn mandalas while you wait on endless voicemail systems for a real person. Or do one while idly watching television (not the "correct" approach, but it actually works anyway, really well!). If you have more energy, quietly go to another room while you color one.

If you have even more energy, draw your own. When you're distressed by a dream (waking or sleeping), make a mandala where each half or each quarter mirrors the other half or quarters. There's comfort in repetition, rhythm, and mirror-image-making (less invention, too). Don't think about the nightmare. Doodle in the circle until you forget that you need to forget your nightmare or until your body settles into itself like a tired child succumbing to sleep. You don't always need to understand the nightmare to bring yourself back. After the terror of the journey, sometimes you just need to know the way home.

ritual

Offer Up Dark Dreams to Nature

It is a misty, chill morning in Kyoto. As I walk under ice-pink blossoms floating in the sky and in the water beside me, I reflect on the night's dream. Jet lag leaves the gate between night and day worlds wider open. Even though I am surrounded by the promise of spring and feel the fine rain dusting my skin, I am still pervaded by my dream. I had not thought to dream such a black dream on my first day in this exquisite city of temples and shrines.

So many temples and temple gardens! I prefer the smaller. Fewer people. Older priests. Less noise. I wander into a side street and enter the temple grounds.

The pine tree is covered in white. It looks like snow but it is not snow on its limbs. It is covered in paper fortunes, each tied to a small branch. These are bad fortunes that recipients have now consigned to return to the gods, to the chill spring air. If the fortune is good, you keep it.

"The basis from which dreams originate seems to be, let's call it with a vague expression, Nature—Nature itself. It's a natural phenomenon."

—Marie-Louise von Franz, in Fraser Boa, *The Way of the Dream*

I think about my dream. There is much of my own darkness for me to contemplate—an inevitable bad-fortune part of my inner world that needs integration. Yet some part of this dream just needs releasing. I stand in front of the tree and imagine the morning's dream written like a bad fortune on a piece of thin paper, the dream images drawn with a sumi brush. Trees absorb pain like rain, judge neither our words nor lack of words, nor signs of love we leave on them.

I imagine sitting quietly and writing my dream and then coming to this temple to silently release the spell of those dream words by tying them to this dark, forgiving, elegant, gray-green pine. I take a deep breath and feel the dream entering a larger dimension than my poor jet-lagged mind, which has a limited approach to the larger wisdom of my dreams.

We do not need to live in Japan and have a temple close by to be able to come to more peace with the dark mystery of some dreams. This blessing and releasing of dark dreams beyond our immediate understanding is a ritual we can enact in our own garden or in our own ways. We, too, can call upon the greater patterns and wisdom of nature to contain what feels too big for us to contain.

> The dreaming self is concerned with anything that interferes with its connection with other human and sometimes nonhuman beings. This is accomplished chiefly through visual metaphor.
>
> —Fred Alan Wolf,
> *The Dreaming Universe*

We can write dream images or tales on thin paper (even bathroom tissue), tie them to a tree in the garden, watch them slowly become absorbed by the elements. We can find bark from a tree and, like the Australian aborigines who use smooth bark on which to paint their dreamtime stories, we can write on it and place it in the ocean, up in a tree, in the ground. We can make a paper boat of dark dreams or wrap the words or images from dark dreams around a stone. Then we can bless them and consign them to the elements: to sea, to lake, to earth, to air.

In winter, we can write our nightmares in snow and watch them be covered over or melt. We can write or paint them, and then consign them to the evening's fire—not in order to destroy them but to symbolically acknowledge that the image needs to transform into something less fearful, invisibly assimilated into a larger rhythm and flow of life that we might not understand but trust and accept.

clay

Give Nightmares Tangible Form

Clay directs a nightmare's flyaway energy through breath and body into the clay and brings visual focus and tactile form to the fear, rage, terror, grief. Using clay for nightmares requires small but important variations, best understood by seeing how Jo worked with her nightmare in clay.

The Dark Hag Returns

I am walking through my grandmother's home with my son. I can't find her. My son says, "She's in the bedroom." I find the bedroom.

Instead of my grandmother, a revolting old woman's sitting by the window. I can smell her. Her face is caved in and hawky. Somehow, I know she's killed my grandmother and she's planning to kill my son. I can't get out. I scream at my son to run. He won't. He's more curious than afraid. I scream louder and wake myself. I was so frightened I made sure he was breathing.

Let's review guidelines and see how Jo applied these to her Hag dream.

- *Set a time limit.* There are no medals for bravery in facing the inner world. No one is going to set limits but you (and close others who won't put up with your preoccupation!). Your self-care is your responsibility, particularly when you are exploring nightmares. Limit the time and energy you invest. Jo asked her partner to take her son to school so she could do clay work for fifteen minutes before work

- *Warm up and cool off.* Energy infusing a nightmare is high and difficult to focus. Walk around, jump, stomp, run. Take clay and pummel it. Poke, pull, jab, karate-chop it until your body tires a little. Jo did her aerobic routine and then loosened up her shoulders that were still tense from hurrying and reliving the dream.

- *Set aside the amount of clay.* Decide on the space your clay piece will occupy. Work with a piece that you can either fit into one hand or is too big for both hands. If you are afraid of the image and want to lessen its energy, work with a small piece. If you want to express and exorcise it, use a large piece. Not wanting to take either the time or courage needed for a large piece, Jo chose a single handful.

- *Drink fluids and take breaks.* Excitement and fear heighten adrenaline. We get dry-mouthed, forget to breathe, breathe shallowly. Breathe the dream energy into the clay. Take breaks and slow, deep breaths. For Jo, forming the head came quickly. She made an egg shape, stuck a nose on, put the clay down, then took deep breaths. Now she was getting to the part she didn't like—the features. She needed more energy.

- *Release the body.* Negative responses tighten the body. Muscles prepare for fight or flight, or freeze like a panicked animal. There's no point in working creatively with a nightmare if you come out feeling dreadful. Release jaw, neck, and shoulders. Breathe tightness into the clay. Shake yourself out. While Jo made the face, she breathed out her fear into the clay, putting the Hag's spirit into the clay.

- *Name the piece and photograph it.* Hidden, positive aspects of a nightmare can become clear if we photograph the piece. Black-and-whites are most effective. If you use quick-dry or home-fired clays, you can paint the piece and photograph it in color. Jo took black-and-white photographs of each side. One side was not threatening at all but quite loving. This unintentional "omission" was not lost on Jo. She named the piece, "The Hag *and* the Loving Grandmother."

- *Notice the light in the dark.* Many people notice that no matter how they try to express a nightmare's intensity and ugliness, the piece turns out to have a comical or friendly aspect. Don't oppose this. It is inherent and reveals to us the paradoxical nature of dark images. In certain communities, priests often dress as clowns. This custom is cross-cultural: the divine appears as its oppo-

site—the fool, the child, the court jester, the clown, the joker. Clothed this way, it disarms defenses, breaks down boundaries between physical and mystical, and, by maintaining a paradoxical balance of divine and comedic, pierces our awareness with new insight. This can happen with a nightmare creation: it takes a form that holds terror *and* humor. We cannot *make* this happen; we can only marvel at its appearance after the fact.

- *Consider sacrificing the piece later.* Certain experiences carry dark power only at certain times. Later, we wonder what was so fearsome or are ready to let them go. We can't force a release. Ritual that forces release of energy from a charged situation can be ill timed and destructive. If the dark image preoccupies us to the detriment of our daily life and sense of proportion about ordinary living, consult an experienced, trained consultant. However, there are times when we are ready to move on or when the fearful image has transmogrified. Then it is time to ritually sacrifice the piece. You might smash it, drop it in a lake, burn it, tear it up, or recycle it. Whatever you do, do it with respect, quietness, care, and gratitude for its teaching. Disposing of a piece can evoke feelings that deserve your calm attention. The more Jo took responsibility for the destructive and loving aspects of herself the piece evoked, the less she was interested in her figure. One day, she buried it in the back yard and planted a geranium over it!

Pay homage to the dark wisdom of the soul and the ways it finds to walk us safely through a small part of our own interior hell. Such dreams help us glimpse small parts of archetypal terrors in a way that does not compromise our daily orientation to waking life. The

nightmare can transform. We can assist by bringing it, through the containment of body and steadiness of breath, into clay. Rather than rotting from neglect, the dark image can weave itself into the whole cloth of our individuation.

The Care and Feeding of Dream Figures and Animals

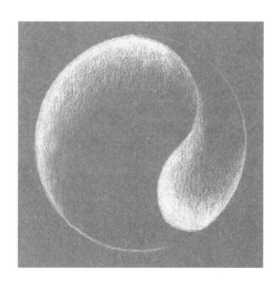

In dreams, we are visited by the *daimones,* nymphs, heroes, and Gods shaped like our friends of last evening.

—James Hillman, *The Dream and the Underworld*

Dream figures can be known, unknown, our personal selves, magnificent characters, or ordinary folk. The extent to which figures represent parts of us seems to vary. At times, dreams are founded more in memory and day residue: we replay a situation at work, rehearse a future situation based on our waking perceptions of our supervisor, our mate, our children. At other times, dreams arise from a deeper level in us: the dream figure does not behave as s/he would in waking life, or has a different personality. Sometimes, the dream figure can be someone we have not thought about for years. Some figures are completely unknown, a creative gestalt provided by our psyche—a figure in a myth, fairy tale, play, fictional story, or painting.

Regardless of the waking or dreaming origin of dream figures, we need to hold figures in a middle realm of reality. We cannot always explain them away by seeing them only as "just my aunt." My aunt is not just my aunt in my dream world. She is my *experience* of my aunt— and of myself through the form of my aunt—at that moment. This dream is *my* dream, as unique in its re-creation of the waking world as my tone of voice, my way of physical movement, my food tastes.

If I am color blind, I cannot perceive the color red. Something inside me has to carry the possibility of "red" before I can perceive it. So, too, in my inner imaginal world: I cannot perceive my aunt's grace or spirited approach to her life if I do not have an intimation of my own (realized or unrealized) grace and high spirits. Someone else will dream about my aunt differently. And I dream about my aunt differently on different days. However, at this moment, my aunt's grace and spirit is what is reverberating in me.

Nor can we distance ourselves entirely from dream figures by seeing them as "unknown people in clown costumes." Diminishing them does not work. Yet neither can we turn every dream entity into a mythological being who has nothing personal to do with us but comes to offer portent of the future. Each of these possible responses does have a place at times. Fixed adherence to any one of these approaches risks diminishing or aggrandizing the figures so much that they cannot help us in that middle realm.

The practices in other chapters in this book work with a variety of dream energies, from human figures to animals, from inanimate objects to themes, from colors to patterns. Most commonly appearing are human figures and animals.

Each theory offers a different perspective on dream figures. How-

ever, the most common question all theories address is, Do these figures really represent their counterparts in the outer world or do they represent parts of us? It is probably the "or" in this kind of thinking that is confusing. It forces us to decide between alternatives.

A less dualistic position frees us to see dream figures on a continuum. At one end are strange, unknown figures who seem to personify some unfamiliar aspect of our psyche. At the opposite end appear known figures who act like themselves in waking life and with whom we seem to move through ordinary situations. Most figures, however, slide up and down the continuum: familiar figures act "out of character" or in magical fashion (coming alive when they are dead in waking life, being generous in the dream whereas in waking life they are selfish); unfamiliar figures act like "real people" yet they are pure products of the dramatist within.

These figures need to exercise a "both . . . and" approach. They are, at once, built from the clay of everyday interchange and experience and fashioned by the unconscious in such a way as to make them unmistakably symbolic of some known or unknown part of ourselves.

Jung's theory is probably the most comprehensive in its treatment of the psyche's personifications of itself. Just as the Hindu worldview provides endless names for and personifications of the divine, thus permitting subtle differentiations among the personalities of gods and goddesses, so too Jung's theory provides for differentiated energies within the psyche. If you are familiar with or interested in Jung's approach to archetypal figures—such as the anima, the animus, the persona, the shadow, the mother, the father, the senex, the wise old woman, the puer, the puella—consult Jung's collected works and excellent contemporary introductions such as Harry Wilmer's *Practical Jung,* June Singer's

Boundaries of the Soul, and Robert Johnson's various books such as *He, She,* and *We.* These are but a few of the clear and succinct books on these subjects. There are equally fine studies of single archetypes too numerous to mention.

A brief introduction to these archetypes would create several unhelpful outcomes: it would do the theory a disservice; it would frustrate those who know more; and it would frustrate those who want more. So, instead, let's review some general ways to view and work with dream figures.

Care for Figures We Know

Here are some questions for you to muse as you consider the familiar figures who masquerade as themselves in your dreams:

- What is/was my connection to this person?
- If I were to describe this person in three adjectives, what would they be?
- Do I like/dislike this person or am I indifferent?
- When do I feel like, act like, or look like this person?
- What do I know about this person that stands out at this instant from all the things I know about him/her?
- What positive and/or negative aspects of myself does this character remind me of or introduce me to?
- Is this person behaving in ways that are atypical of waking life? When do I notice those behaviors in myself?

Care for Figures We Don't Know

You might consider the ever-changing answers to some of these questions about the unfamiliar people who are walking through your dreams:

- How fully can I describe the figure?
- What three adjectives would I choose to describe this figure?
- What is my relationship to this figure?
- What role does the figure play in sustaining or changing the direction of the dream?
- What feeling or tone does this figure add to the dream?
- What name would I give this figure or does this figure have?
- If this figure had to represent one quality alone, what would it be?
- What is the age of this figure in the dream? What is my age? How would the dream feel different if the figure were a radically different age from the figure currently in the dream?
- What can I imagine this figure's personal history to be?
- What aspects of myself does this character remind me of or introduce me to?

Care for Same Sex Figures

Same sex figures can often be overlooked in a dream. However, their particular qualities and their relationships with each other and with our

> "One should always first ask, 'What is it in me that does that?' instead of taking the dream as a warning against other people."
>
> —Marie-Louise von Franz, in Fraser Boa, *The Way of the Dream*

dreaming self can lead us into surprising insights as we ask one or more of these questions:

- What is our relationship in the dream? Does this remind me of waking relationships?

- What about our personalities is notably alike, either positive or negative or both?

- What about our personalities and our actions is quite different, either positive or negative or both?

- If I were to employ this person in real life, the most constructive position for this person would be . . .

- How would my feeling about this figure change if the figure were to turn up in the same dream as the opposite sex? So what does the figure's being the same sex add to the dream for me?

- The task for which this figure would be least suited would be . . .

- If this figure had to represent one quality alone, what would it be?

- What is the age of this figure in the dream? What is my age? How would the dream feel different if the figure were a radically different age from the figure currently in the dream?

- What might this figure's personal history be?

- What aspects of myself does this character remind me of or introduce me to?

Care for Opposite Sex Figures

Opposite sex figures intrigue us, particularly regarding our relationships with them in our dreams. Sometimes a wonderful relationship with an opposite sex figure can be as disconcerting as a troubling one because it feels so real and makes our daily relationships pale in comparison. Here are some questions for you to muse over concerning any kind of figure of the opposite sex:

- What is our relationship in the dream? Do I have this quality of relationship with waking-life people of the opposite sex?

- How would my feeling about this figure change if the figure were to turn up in the same dream as the same sex? So what does the figure's being the opposite sex add to the dream for me?

- What are this figure's most outstanding characteristics? What three adjectives could I give to describe this figure?

- What is the age of this figure in the dream? What is my age? How would the dream feel different if the figure were a radically different age from the figure currently in the dream?

- When do I act/feel/imagine myself to be seen like this figure in waking life?

- What might this figure's personal history be?

- What aspects of myself does this character remind me of or introduce me to?

> According to Aboriginal thinking, dreaming is necessary for our recognition that we belong to a whole greater than our mere individual selves.
>
> —Fred Alan Wolf,
> *The Dreaming Universe*

Care for Magical, Mythical, and Divine Figures

At times, the figures in our dreams have remarkable qualities of being or action. We recognize, either in our dream or when we awake, that this figure is beyond our normal conception of what it is to be human. Magical, mythical, and divine figures can be pleasant or unpleasant to encounter—but each kind is well worth your exploring.

- What is the nature of this figure's special powers or qualities? How can I describe them as fully as possible?

- If I were to imagine that I have been apprenticing with this figure for a long time, what have I learned (both good and bad) from this figure?

- What might this figure's personal history be?

- What aspects of myself does this character remind me of or introduce me to for the first time?

- If this figure were to appear in a panoply of gods and goddesses and were to be given a name that described his or her essential nature, what would s/he be named?

- Do I feel familiar with any aspect of myself that sometimes is able to exhibit this quality?

- Does this figure represent something in me that feels very far from who I am? Can I imagine taking that figure inside of me and letting it operate? How would it feel?

Tend Your Dream Animals

So much fine (and mediocre) material has been published on the symbolic meaning of animals in our dreams, inner journeys, meditations, and active imaginations. If you are not already familiar with this material, visit your local library or bookstore and leaf through these books. But before you get absorbed in reading about the symbolism of elephants, rabbits, and spiders, first reflect on your own associations to the animal who visited you in the night. Below are some different ways you can enrich your associations.

Meditate on Your Perception of the Animal's Spirit

Explore your personal associations to the animal. Then write down everything you know (or think you know) about this animal's

- Character
- Habitat
- Food choices
- Method of getting and eating food
- Elimination
- Procreation methods
- Gestation
- Birth
- Life span
- Sleep patterns

- Relationships with other animals
- Relationship to the environment

Include what you might think are positive as well as negative descriptions. This list represents your subjective-objective take on the animal. Circle information that seems to parallel aspects of your own character.

Learn about the Life Cycle of the Animal

Look up a reference book and read up on the facts about each of these categories. Note down anything that attracts you or deeply bothers or amuses you. Work with group imaginative perceptions of the animal. If you are working with a group of dreamers, spend time with your group brainstorming about what they associate with certain animals.

Research the Animal as Symbol and Mythological Figure

When you have finished with the remembered or researched aspects of the animal's actual life, use reliable reference books to research what this animal has been cross-culturally associated with in mythology, heraldry, religious ritual, and worldviews.

By doing this, you can create a delicate web of associations, a double helix of connotations that moves in and out at the same time. One spiral moves from your dream image outward into the conscious associations you and others have with this image. The other spiral moves inward; each outer association you discover flows back

> "The dream ... is a message of yourself to yourself.... Every aspect of it is a part of the dreamer, but a part that to some extent is disowned and projected onto others."
>
> —Fritz Perls, in Joen Fagan and Irma Lee Shepherd (eds.), "Four Lectures"

into the psyche and waters and fertilizes the roots of the image in the psyche. Don't expect to see flowers. You are fertilizing the root system of your image and other images that are rooted and growing close by. Amplifying your dream images is an excellent way to enrich the image; keep returning to the original image as home base.

—

Expressive Dream Work
with Recurring Dreams and Series

"Dreams always point to the inner center. They are like hundreds of forms all pointing to the inner center. Every dream is an attempt of nature to center us, to relate us again back to our innermost center, to stabilize our personality."

—Marie-Louise von Franz, in Fraser Boa,
The Way of the Dream

Dream series are amazing threads in our soul's tapestry. A series can be developmental, repetitious, increasingly archetypal, or increasingly threatening (until we pay attention). It can also give new perspectives on an old theme.

A series that chooses the same topic, theme, or symbol is easy to trace if you keep records. (Some dreamers use the "Find" function in their word processing programs to locate themes.) When you have time, review your dreams for clear, repeated entities, themes, symbols, or images.

Don't get lost in interpretation. You can use other ways to approach topics, themes, and symbols and to use your intuition in understanding repeated dreams.

Ever since she was young, Robin had dreamed of dragons. How Robin approached her dragon series reminds me of a show by the painter Nathan Oliveira that a friend and I attended at Stanford University. There were many paintings: some about six inches square in oils or watercolors; others, oils as long as the whole gallery wall, as high as the ceiling, and layered on, resulting in striking and evocatively mysterious pentimento. Every painting was of a kestrel, a kestrel's wing, or essence of kestrel.

How did this series begin for Oliveira? On the day he first moved into his studio at Stanford, a dead kestrel was lying on the doorstep; there was also a stuffed kestrel that had been left in the studio. He brought his imagination and love to those birds. He let them fly. Had he "figured out" what the kestrel meant to him, "why" it had appeared on his doorstep, he might not have had the gift of these magnificent paintings. Instead, he sought, in this series of paintings over many years, to keep the spirit of his connection with the kestrel, to preserve its mystery. As I looked at his paintings, I felt as though I were dwelling not only in the heart of the kestrel and soaring with it but in the heart of the painter.

This is how Robin approached her dragon dreams. Certainly, she researched the mythological, religious, and cultural history of dragons. But she did not do this to pin her dream images down. Rather, she allowed her imagination to roam over her amplifications around the dragon, allowed her soul to be fed by their numinosity without getting big-headed or terrified at such magnificent appearances. She treated her series as she would have treated the unexpected but repeated arrival of a mysterious, eminent guest who always left the household richer, wiser.

It is the cumulative numinosity, mystery, or ritual repetition of an

image that gives a dream series its power. No matter what you create, treat your dream series with as much respect as Oliveira showed the kestrel in all its forms—whether dead on the doorstep, stuffed on a stand, or soaring above the Stanford hills, forever mysterious, powerful, and free.

Across time, dreams can reveal inherent patterns, repetitions, or coherent variations on a certain figure, perspective, color, place, season, feeling, structure, or theme. One woman dreams about her childhood home all the time. It doesn't matter what's taking place in the dream or whether her husband and children or old loves are there; she is somewhere nearby or in that house. Another dreams of submerged rooms; another dreams of tidal waves; another dreams of dark streets in an unfamiliar town with shadowy figures chasing him.

We can imagine many reasons why certain images repeat. Some theorists see these repetitions as symbolic attempts to resolve unresolved issues; some see them as constellations of psychic stars endlessly circling around some benevolent or malevolent sun in our personal or collective experience. No matter what the reason, if we pay attention to the evolution of the series, these recurrent themes and images leave us a little more conscious after each visit.

To shed light on dream series and recurring images, you can use any of the practices mentioned elsewhere in this book. Certain practices, however, work particularly well with repeated or evolving images.

Visit an Art Gallery of Repeated Images

imagination
writing

Read through your dream journal. Each time you come to a particular recurring theme, create a title, capitalize it, list it, and date it on a

separate piece of paper. Put these in sequential order. Here is one dreamer's list of titles:

Tidal Wave over the Office Block

My Sisters Are Caught by a Tidal Wave

Night Tidal Wave

I Ignore the Tidal Wave

Tigers in the Tidal Wave

Tidal Wave Breaking against our Window

Surfing the Tidal Wave

After you have titled, dated, and listed all the dreams around a theme, look at the list and imagine this is your gallery guide: these are titles to art pieces. In your imagination, walk around the gallery and look at each painting in turn. Imagine these images are rendered in different styles. Some are large, some small, some in vivid relief, some in watercolor, some in oils.

What is your response to the images? Take time walking and looking. What kind of a gallery is it? What kind of people are looking at this show? Eavesdrop. Listen to how they respond to the power of these images. What do you see or feel about your theme after viewing it in this way?

reflection
notetaking

Amplify Associations

To enrich your associations to a repeating symbol, notice what happens to each dream if that image is removed. What was it that this image

contributed to each dream? By following this image through a series, you develop a cumulative sense of the function of that image, metaphor, or symbol in your inner world.

Stella took the image of high seas and skimmed through her dreams to see what the image contributed to each dream. Here's an excerpt from her list.

Dream 1—tossed about, powerful, strong

Dream 2—threatening, without care for those drowning

Dream 3—sailing on—making it but only just...

Dream 7—setting out on high seas; using winds and waves to make forward motion—feel the surging power moving boat forward...

Dream 11—surfing big waves—dumped but go right back again—waves helping me to do what I want—serious playfulness.

The image of the high seas shifted for Stella over time—from something threatening to something she could use once she learned how. She had not noticed this development until she wrote out each dream's contributions.

> It is not to be bemoaned that imagination has no conventional language of its own (except the word-play of image), for imagination seems to turn this weakness into an amazing grace.
>
> —James Hillman, "Image Sense"

Visit the Rogues' Gallery

Our wonderfully plagiaristic inner artists use the same figures in different dreams at times—especially friends, family, and colleagues. Especially intriguing is how a particular figure appears across time. One

reflection collage

> "The dream figures have a life of their own, totally and utterly different from mine, and they are elements of my soul. They are myself and not myself at all."
>
> —Robert Bosnak, in Michael V. Adams, "Image, Active Imagination, and the Imaginal Level"

dreamer discovered that her mother was always about to say something the dreamer could never quite catch; another saw that the dreams about her father evolved from his being a distant, fierce figure to being loving and physically vulnerable.

In addition to the appearance of people with important roles in our lives, odd folk appear: an old school friend, a passing acquaintance. Appearing once, these figures bring their own curious flavor to a dream: they contribute something no one else could have contributed. Appearing many times, they take on more import. They are mysterious figures in a subplot. They are like a recurring leitmotif, a painting gesture, a design on a pot. Brainstorm your associations to the figure:

- What functions does the figure perform in each dream?
- How does each dream change if that figure is left out?
- What does the figure contribute to each dream?
- What are five positive and five negative adjectives I would use to describe this figure?

If you are still intrigued by the figure's appearance, make a collage of photocopied photographs of this person. Meditate on it for a few minutes a day for a week. What else does the image evoke? Something of you?

painting
ritual

Work with Repeated Actions

One action rarely makes a ritual unless done with great consciousness.

More often, ritual involves conscious repetition of actions that are imbued with symbolic significance.

Repeated activities are common in dreams. Again and again we fly, walk on the beach, fight with dark forces in alleys, give a speech, run late for class, have a love affair with an old acquaintance, leave our wallets at home. It is easy to focus more on the *content* of what we are doing than on the action: the beach, the wallet, rather than the walking, the losing. What links these dreams together is the activity.

Dreams show remarkable flexibility about moving back and forth between language or imagery. A theme can appear in the imagery; it can appear in words that describe the dreams—word play, puns, names, symbols. These dreamers show us different modes:

Piercing

Something gets pierced—over and over. I'm a little girl getting my ears pierced. I describe a cry as piercing, a sunset as piercingly beautiful. In several dreams I'm pierced by something but it doesn't hurt. In others, I'm watching my wife prick her finger as she sews.

Digging!

I can't believe how many digging ideas turned up—dogs digging up bones in the garden. I'm "digging up dirt" on someone. My daughter's making digs at me. On and on. It's really a theme!

Review your dreams to see whether you are being or acting in repeated ways in different contexts. Imagine these activities are repeated in a series of paintings in a gallery. What seems to want to

make itself known to you through these dream paintings? Alternatively, mime the repeated or evolving actions. What emotional reactions do you have, what is evoked in your body, what images come? Do an energy painting, letting it hold all the subtle shifts in function of these images across all the dreams in one paradoxical whole. You might even wish to create a ritual sequence of movements that embody and formalize these repeated actions or gestures.

collage

Explore Repeated Times of Day and Season

Many dreamers notice their dreams seem to take place in the same kind of light—deep gloom, an unearthly pale light, dim natural light, midnight. Others also observe that a particular season reappears. Something about that time of day or that season carries special importance. Times of day and seasons are very receptive to collage. Here are some ways that these themes appeared to dreamers:

Nighttime

It's often nighttime in my dreams. In fact, when I went back over a lot of dreams, I either didn't know what time of day it was or it was night. Moons, stars, candles, dark paths, dark streets, talking in the dark, dark forests.

Snow

I have endless dreams about being in snow. I always know what time of the winter, too.

The "snow" dreamer worked with his associations across the dream series and saw that they had a double connotation for him: he thought of snow essentially as clean, beautiful, and untouched; he also thought of snow as covering up and freezing things. Both themes touched on certain of his values and actions that distressed him.

Explore Repeated Colors

collage
painting

Wander through your dream journal and notice whether colors repeat themselves. Colors can repeat themselves in words as well as in image, as these dreamers illustrate:

Blue

Feeling blue, seeing blue rooms, buildings, clothes, blue ice, ocean, turning blue with cold . . .

Black and White!

White shirts, newspapers, white walls, snow, night, a black dog, a black and white tiled floor, a black mood, a blackout. . . . I have to wonder whether I'm a black and white kind of person!

How does the color contribute to each dream? How do the images accumulate into an overall feeling about the color? Work with your amplifications. When you have finished, list your associations to the color. Make a collage or energy painting that features the color, following the suggestions in earlier chapters.

drawing
painting

Map Directions

Directions are less obvious in dreams unless we begin to look at a series and see what visual movements and *words* associated with directions reappear:

Left

Left—going left, being left, turning left, Leftist, left-handed, looking left, I left a place.... I am often traveling in a left-handed direction—whether I'm walking with a friend, or turning left on a road, or dancing, or flying. But I often seem to turn left or circle left. I even notice that I talk about being left in various places.

Repeated movements lend themselves to energy paintings and to mandalas. Begin by letting your body and your hand repeat the movement. Let the hand "wander" or move from "left to right." Let your body "fork" or "spiral." When you have embodied the direction, translate it into line form on the page. In an energy painting, you will let that particular movement evolve as it wishes, either repeated again and again with different brushstrokes or colors or evolving into something else. In a mandala, you might wish to formalize that gesture into a line drawing that symbolizes or distills that movement on the page and repeats it in each of the segments of the mandala.

Now contemplate your energy painting or mandala. What does this evoke in you? Is this familiar or new?

reflection
notetaking

Explore a Repeated Quality

Often, dream actions differ but share a common way of being performed and described:

Fast! Fast!

Everything happens quickly in my dreams. I end up missing some-
thing because it's happening so fast. For example, I was running
for the plane but it took off without me; and in a lot of dreams, I'm
having breakfast—break-fast. Maybe I'm going too fast in my life.
I mean, I can't even catch my dreams!

This dreamer made a list of the benefits and liabilities of being
"fast." Until now she had focused on the benefits—being a quick
thinker, mover, decision maker. She saw she needed to be more aware of
her "impatience" (with others and with herself), of her taking tasks
away from her daughter because she took too long.

Make a list of the positive and negative things you associate with a
quality in your dreams. What does this quality carry for you?

Observe Repeated Feelings and Emotions

reflection

Patterns of feelings and emotions are easy to recognize in a series. We
are continually angry, caught out, frustrated, in love, sexually aroused,
grieving. Explore the subtle variations in these feelings. If you are often
angry in your dreams, for example, ask yourself: What touches off my
anger? Is it always something minor? Does the trigger change over time?
Am I always feeling the same degree of anger? Does anyone respond to
my anger? How?

Carolyn constantly dreamed of trying to make a place for herself at
work. She would crawl under tables groaning with food. She would
wait to get her manager's attention and he would leave without
speaking to her. In reviewing these dreams, she noticed that she was

gradually contending with fewer obstacles. Finally, she dreamed she told a co-worker not to interrupt her conversation with her manager, turned back to the manager, and continued talking. After this dream, Carolyn had no more dreams about trying to make a place for herself at work. Her outer behavior had been shifting over time, and the dreams acted as both a reflection of the changes she was making and preparation for future changes.

multimedia

Use Different Media for Recurring Images

The more an object or entity stands for itself in a particular time and place, the less it is a metaphor. The more it stands for something else, the more it takes on the function of metaphor. When it stands for something else consistently over a period of time, it becomes a symbol. The snake that appears once is an image with possible metaphoric and symbolic overtones; the snake that appears twice is beginning to stand for something in the soul; the snake that appears again and again takes on the authority of a personal symbol in our private mythology.

As you unearth these images that have earned the status of "symbol" in your inner realm, use the practices described earlier to pay homage to them in the outer realm and to consolidate their place in consciousness:

- Find a stone that looks like the symbol in your dreams.
- Make a collage of images; one woman dreamed repeatedly about infant girls. Over weeks, she collected pictures of infants from magazines and then combined them in a collage. She also included color copies of herself as a baby. Another man had a recurring experience of flying that he decided to represent by

painting a blue background and adding pictures of wings onto which he pasted photocopies of her own face.

- Write a poem including different situations in which this symbol has appeared in your dreams.

Alternatively, choose one of these ways of acknowledging and harnessing the energy of these symbols that orbit in your inner universe:

- Make a mobile that includes pictures (photocopies) of several entities that have appeared in your dreams. Hang it near your bed (assuming no bellowing objections or ribald comments from significant others). Or hang it where you do your dream explorations during waking hours.

- Make a mandala that allows a formal place for each symbol. Draw the mandala form on a white or colored board, allowing equal space for each symbol. Place each on it at will, changing them every few days according to which symbol seems to belong in which space.

- Make a special box covered in simple but pleasing paper in which to keep photos or other visual replicas of your symbols. Every so often, add another, or quietly leaf through them.

- Collect a series of small figures from different tribal and cultural groups that somehow capture the spirit of your visiting spirits. Put them in a protected and private place.

> When a person is informed about a situation, an older person will often use a parable, an axiom, and then add to the end of the axiom, "Take that as deep talk." Meaning that you will never find the answer. You can continue to go down deeper and deeper. Dreams may be deep talk.
>
> —Maya Angelou, in Naomi Epel, *Writers Dreaming*

In this way, you can explore the image without killing it; you can feed it so that it can continue to feed you.

painting
movement

Map Structural Patterns

Repeated narrative structures in dreams can reflect patterns in our outer or inner life. Recognizing them can free us from an unconscious need to follow grooves deepened over years; recognizing these grooves gives us choice to change.

Lucy spent months exploring a series of epic-length dreams apparently unrelated in image or theme. She had made good inner and outer use of her insights but believed there was a deeper connection. She asked herself, "Does this series have anything *unusual* in common?"

She realized her dreams had similar lines of development. She mapped out with pastels on paper and then with her body in movement the energetic movements of the dreams; each began with a slow, non-directional action followed by faster, direct action that was then cut across by a counterforce strong enough to permanently alter the original action. The counterforce would then disappear, but the narrative would continue in the new direction without much force. She realized, "This is what always happened to me with my uncle! I spent lots of time with him. He was a fine artist and he did teach me. But I'd start a drawing and he'd grab my pencil and change my lines. I learned but I didn't want to draw any more. I lack confidence in my life. Just when I'm getting in my stride, I let my judgment get derailed. I've been letting this run me without my knowing it!"

Over the next months, this pattern lessened in frequency in Lucy's dreams. This insight was just a beginning: it was up to her to take

responsibility for her own capacities and to be an encouraging authority for herself. Lucy began to be an advocate for her own creativity. Her recollection of her childhood experience and its anachronistic influence on her adult life began the long journey across psychological time zones to catch up with the rest of her adult conscious life.

> A dream is not a story, not a movie or text or a theater play. A dream is a happening in space, an articulation of space.
>
> —**Robert Bosnak,** *A Little Course in Dreams*

Look for Perspective

observation
reflection

Noticing the repetition or development of perspective in a dream series alerts us to ways in which we might be approaching our lives. For example, a young dreamer who was always on the outside looking in realized that this was her experience of family life when she was growing up. Another dreamer noticed, "I see everything close up—I rarely see the whole—a face, a hand, a toy." It didn't take a degree in symbology her to realize she might need to step back from situations to be more effective!

Continue to work with repeated dream images until they lose efficacy, until you forget to look at them for a long while, or until they bore you. Your connection to them will have lived a full life, and that energy has evolved. Don't hold on. Accept, be grateful, and move on.

Enriching Dream
Work in Groups

> A thousand and one reasons occur to you for
> not working on your dreams today, especially after
> your first enthusiasm has waned. Thus it is important
> to work on dreams together with others. . . . With
> their help, your habitual consciousness can stay
> with images that it would otherwise flee from in
> subtle ways.
>
> —Robert Bosnak, *A Little Course in Dreams*

There are two schools of thought on telling dreams: one says we should and one says we shouldn't. The Senoi people pay such communal respect to dreams that they tell them to each other regularly. Our society rarely has time for or values this kind of gift. How many of us have friends, family, children who are going to pay rapt attention to our fuzzy sagas in preference to reading the comics over breakfast? While our dreams are of high interest to us, they are rarely actively valued by anyone else except our dream group or therapist.

Telling a dream to an unreceptive or insensitive audience is like feeding paté to a puppy. It's a waste of good spiritual food and diminishes dream and dreamer. Many New Guinea villagers were wary of my camera, believing their spirits might be captured and whisked away. While their reasons for not wanting their photograph taken might evolve from a different worldview from ours, they were wise in wanting to protect their souls. Be wary of letting unappreciative people snap your dream up and either dismiss it, ride roughshod over it, or analyze it to death (usually in their best interests, not in yours).

Share Dreams with Trusted Others

I shudder when I see people in large workshops share intimate, important dreams. Right atmosphere, respect, and understanding are rarely present. Most people have not learned to listen to others' dreams with enough sensitivity to accept their individual, community, and cultural value. Be cautious. You can rarely go wrong by not sharing your dream, but you can often lose its spirit or energy by telling it too soon or to the wrong person. Although you might love your partner, family, and friends dearly, they are not automatically the most sensitive audience for your dreams.

Here are some criteria for sharing dreams with others—either one person or a group:

- Do the receivers really want to hear it?
- What do I want from sharing it? Have I been explicit?
- If I just want a receptive audience, have I been clear about that?

- Do these people have a lived sense of the reality of the inner world?

- Do these people have a developed sense of the symbolic realm or will they take my dream literally (or personally)?

- Do they really have time to hear my dream and reflect on it?

- Am I willing to hear their dreams as well? Do I want to? If not, is it acceptable that one of us might tell and one might not?

- Have we all set a considerate context in which to do this or are we finishing up lunch in a noisy restaurant, driving in commuter traffic, or rushing somewhere?

- Do these people know anything about dreams and theories and creative approaches to dreaming? Does that matter to me?

- Does it matter that they share the same approach to dreaming that I do?

- Can they keep my dreams confidential?

Set a Context for Dream Work with a Partner

Sometimes you will be fortunate enough to be able to explore your dreams with one special person: your spouse, partner, or close friend. Sharing dreams with one valued person adds spice to the soup and requires careful handling! So, in addition to the criteria just listed, consider following these basic guidelines.

- Set aside ten minutes for each dream.
- Alternate going first.

- Ensure a quiet, uninterrupted environment. Answering a telephone call or doorbell disrupts the flow of attention and the capacity to imaginatively enter the other's world.

- Be in harmony before you begin. If you are at odds with each other, don't exchange dreams. Your partner will be tempted to receive the dream more like a surrendered weapon than a delicate newborn.

- If you believe that a dream can offer a peaceful solution to a current difficulty with your partner, share the insight first. Follow later with the dream.

- Save discussion of dreams for this time only and refrain from either telling new dreams or commenting on earlier ones at other times. There are always exceptions, but ensure you both agree about the exceptions. Otherwise, it renders the time set aside less precious.

> Dreams are ... important to Mayans ... and public dream narration and interpretation are commonly practiced. All over the Mayan region it is routine to awaken one's spouse, or other sleeping companion, in the middle of the night in order to narrate a dream ... and in some communities mothers ask their children about their dreams every morning.... Among adults, important dreams are shared with initiated shamans who are dream interpreters....
>
> —Barbara Tedlock, "The Role of Dreams and Visionary Narratives in Mayan Cultural Survival"

Explore, Don't Interpret, Your Partner's Dream

Interpretation itself is delicate, skilled, and uncertain surgery, even in elegant and experienced hands. If your only goal is to gain insight into daily life, you will probably focus on coordinate points between waking and dreaming states—an approach that bypasses most archetypal and cross-cultural approaches. If you want clues for waking life, then, by all means, look for

them, but don't take dream "clues" literally. Dreams can't be literal; they can appear logical and causal and related to daily life—but so can a film. Dreams can be analogical, metaphorical, alchemical, but they won't ever be literal—so beware of taking concrete advice from a dream. And even if you're fortunate enough to have a prophetic dream, it's unlikely that you'll know it. So, insatiable curiosity, creativity, and humility are the best guides.

If you wish to do more intrapsychic and analytic work with your own and others' dreams, make sure you agree upon and are well versed in a particular approach such as Jungian or Gestalt. In dream work, a little knowledge spread thinly is dangerous; much knowledge laid on too heavily, suffocating. Both accord false authority to the interpreter and diminish dreamer and dream.

Better still, unless you are in a group devoted to working with dreams in a defined context with clear parameters, eschew interpretation. Rather, develop a series of questions along the lines of those following, questions that help a dreamer go more deeply. You and your dream partner or group can ask each other such questions. Clearly, you won't ask all. (Some dreams take ten minutes in the telling!)

- What was the feeling with which you awoke?
- What questions do you have about the dream now?
- Do you have any immediate sense of a message or situational reading from the dream?
- How might you explore this dream creatively? What media might you use to explore this dream further?
- What are the most arresting images in this dream for you?

- What are your strongest associations to any of the objects or people in this dream?

- Do any of the objects or people seem to symbolize something to you? If so, what might they symbolically evoke cross-culturally, archetypally?

- What would your title for this dream be?

- What would you most like me to remember about this dream?

Choose questions that encourage you and the dreamer to hold the dream respectfully. Once again, remember to receive without judgment, without clever interpretation, but with quiet attention, curiosity, and caring dispassion. Too often, it is easy for us to unconsciously drive points home that we have been wanting to make. ("Gee, I see a weight issue in this dream!"; "Hmm, forgetting things again, huh?"; "I thought your sexual attention was elsewhere!"; "I knew you were upset about that dinner party—see, it's right there!") If you are going to treat your partner's dreams with the respect they deserve, you won't use them to benefit your position in the relationship.

Receive the dream as a human gift. It doesn't matter how dark or bright the dream is. It is still a gift of trust and imagination given to you from another's inner life, an opportunity to walk in your partner's inner world for a few moments. In certain improvisation games, participants practice being grateful for whatever wild opportunities are thrown their way by fellow actors. This attitude of active receptivity is crucial. Appreciate what your partner has given, no matter how hard, boring, scary, or disconcerting listening to it was for you. You are being given a unique creation just like a painting, sculpture, or poem.

Celebrate What's Unique and What's Shared

A paradox of the inner path is that the more individualized and indi-viduated our responses become to our experience, the more universal they seem to become. Think of poetry you have read and paintings you have seen: both reflect one person's experience of the world as well as a universal truth. When we receive, copy, or merge our experiences with others', we end up with stereotypical images; when we accept our uniqueness, we vitalize archetypal images.

Sharing our uniqueness with others provides them and us with ways to connect on a universal level. Talking about dream work with trusted others reminds us of wider, deeper dimensions of human experience.

Expressive dreamwork groups can be successful with as few as three people and as many as ten. When we talk simply and honestly about what we are learning from our own expe-rience, others also learn. Even when we describe something painful, talking about it *with dignity and self-respect* can be deeply healing for others as well as for us. I have seen group members talk in one meeting about creative pieces that came from dreams they associated with joy, humor, death, abortions, shame, separations, guilts, playfulness, healing, confusions, and fears. The group's willingness to accept all experiences and their loving observation of their own humanity allows all member participants to view them-selves with dignity and to remember that pain

> [In] … the Iroquois midwinter dream festival … small groups of men and women invaded dwellings, overturning utensils and creating chaos, while miming the content of especially significant dreams. They did not leave until the "soul wish" of the dream had been guessed and either ritually enacted by the occupants and/or assuaged by a suitable gift.
>
> —Harry T. Hunt, *The Multiplicity of Dreams*

and joy may be drawn from separate wells but spring from a common artesian river.

Select Your Group Members Carefully

Working with a group that is exploring creative expression both deepens and broadens possibilities for interaction. When you sit and talk with one other person, there is only one avenue for learning: your mutual interaction. When you meet and share creative work with a group, you can choose to respond to the art piece itself, to its creator, and/or to the whole group.

If you are seriously interested in forming a group to explore dreams through creative expression or some other approach, do some reading on dream groups in addition to what I outline. Then find four to six like-minded peers who wish to explore together.

Give the Group a Ritual Form

Keep a two-hour period to meet weekly or bimonthly at a regular time (the unconscious seems to like regular rhythms). The beginning of your

time together can be simple—sitting in a circle in silence or listening to quiet music for two minutes helps everyone quiet themselves and focus. The ending can repeat the opening. It doesn't have to be complicated. It simply needs to be there. Without an ending, the group can take longer to shift mood, feelings, and attention from the inner world to the outer.

How do you structure the time in the middle? Plan it however your group wishes. Your group might like to consider some of the following approaches. Of course, the format needs to simplify with increasing numbers.

Practice Acceptance and Nonjudgment

Your group is not engaging in psychotherapy, dream therapy, art therapy, or art criticism. However, you can attend to the inventiveness, mystery, wisdom, and humor of dreams. Your group can focus on ways to integrate dream material. Knowing this is neither therapy nor an art class can free you; there is nothing for you to *do* with someone's pain, puzzlement, or joy other than to acknowledge, accept, and hold it with loving respect. Retain a spirit of nonjudgmental receptivity, unintrusive curiosity, openness, and appreciation. Clearly, if someone seems at risk, help him or her find professional assistance.

When you listen or watch other group members share something, receive them and their work in an attitude of loving acceptance and nonjudgment. This sounds difficult, but with few exceptions, group members are amazed at how their capacity for nonjudgment is evoked

> "Dream groups are helpful because we can catch each other when we fall...."
>
> —Robert Bosnak, in "Image, Active Imagination, and the Imaginal Level"

by someone else's speaking truthfully from the heart. Something about dreams and the arts evokes larger responses from us regardless of our limitations.

Establish a Framework

At your first meeting, determine clear guidelines for your group work.

- *Establish confidentiality.* Agree at the beginning that everything shown or discussed in the group is private and will not be discussed elsewhere without explicit permission.

- *Take turns.* Ensure everyone has an opportunity to share pieces.

- *Allocate time when appropriate.* Check at the beginning of each meeting how many people would like to share pieces or speak.

- *Respect diffidence and quietness.* Feel free not to bring or share something and accord others the same freedom.

- *Share the experience as well as content.* Talk about the process of making a piece as well as the content. Sometimes the process was effortless but the content, painful; sometimes the process, difficult, and the content, full of delight.

- *Feel free to share dream art pieces without commentary.* Don't push someone who wishes to show a piece of dream art without talking.

- *Feel free to discuss the experience without sharing content.* Sometimes you might want to talk about the experience of making something but neither show it nor talk about the dream because it still feels too private. Trust your reticence. If your intuition tells you a piece needs to gestate before sharing it, wait longer. Trust your timing.

- *Don't withhold out of shame or embarrassment.* Feeling ashamed of a piece, however, is no reason to withhold it. Paint the shame, sculpt it, talk about it—do anything rather than identify with it.

- *Ban spoken and unspoken praise and criticism.* When you focus on another group member's piece, don't even silently praise or criticize it. Oddly, when one is engaging in silent assessment of another, the other picks up a "performance aroma" and begins to self-deprecate. Moreover, withholding judgment from others is good practice for that harder task: withholding judgment from your own work. When judgment arises spontaneously, watch it and let it go. Judgment is a habit.

- *Never apologize for your work or dream.* Never preface your work with apologies. Don't apologize after, either.

- *Ask for what you would like.* Invite the group to respond to your work in one of the ways suggested, or ask them simply to receive it in silence. You might have brought a dream painting of difficult events that are almost too hot for you to handle. You might just manage to share the work, but it would be too much to talk about it. This is good judgment. In an informal group without a professional facilitator, it is wiser to say too little than regret having said too much. Never ask for critical feedback, positive or negative. If criticism is asked of you, gently remind the asker of the purpose of the group.

- *Don't allocate turns.* Let whoever feels like going next present next. Going around in a circle heightens anxiety and encourages rehearsing.

- *Acknowledge and provide transition.* Always acknowledge a presenter for bringing and/or talking about a piece. Then allow a

> The Iriquois ... had special dreams that they interpreted as messages for the group.
>
> —Carl W. O'Nell, *Dreams, Culture, and the Individual*

moment's silence to change focus from one person and mood to the next.

Use Every Medium from Mime to Song

There are several responses you can offer a presenter. Remember that s/he is the center of the group's attention right then; if the presenter's piece reminds you of something in your own life, only talk about it in a way that respects the current focus on the *presenter's* experience. You could also thank the presenter for putting words or images to something you have experienced but not articulated. Certain responses can help presenter, piece, and group:

- *Associate to the piece.* Give the creator three descriptive, sensate adjectives that come to mind as you look at the work. These are not adjectives of praise or criticism but ones that describe a mood or movement, for example, "sinewy," "flowing," "jagged," "bright."

- *Allow others' imagery to nurture yours.* Allow other dreamers' pieces to jog your sensitivities about your own dreams and experiences—do they help you understand yourself better? For example, "Until I saw your sculpture of that demon, I never thought demons could have a comic side. I'll look at mine anew now!"

- *Explore dream miming.* Groups work well with mime. Whereas the verbalized dream might seem too revealing to share, we can often tell the most penetrating, personal, or private dreams in a group through the grace of mime. Ask that group members simply empty their minds and open their hearts. It is not the time to

interpret or judge. Nor is it the time to admire others for how well they can mime or for comparing themselves with the person currently miming. Focus loving attention on the mimer in a way that seals off the outside world and makes a safe, invisible container in which the group and individual performer can operate without fear of betrayal, nonreceptivity, or interpretation.

- *Make up a story* to go with the piece (keep it short).

- *"Dance" the piece as a group*—that is, move to it. Follow its lines or let its mood move you.

- *"Sing" the piece as a group*—even paintings can be "sounded" if you put your rational mind aside—it won't sound harmonious but it will generate energy! Again, let your voice follow the lines or express the mood of the piece.

- *Read poems twice.* If a dreamer has written a poem, invite someone else to read the poem a second time so that the writer can hear its cadence and rhythm afresh. This is a gift to the writer and surprisingly moving. Invite the writer to read the poem, also, in his or her native language if it is not the first language of the group. The speaker can usually feel much more at one with the message and mood of the poem written in a first language.

> Interpretation of dreams and their associations is familiar to all [Senoi] adults and an essential part of bringing up children.
>
> —Kilton Stewart, "Dream Theory in Malaya"

Don't Compare. Appreciate!

Professional artists use others' work to inspire, not to discourage themselves! They plagiarize with proud abandon and in the most honorable of traditions.

- *Don't say something for the sake of speaking.* If you have a feeling with no words to accompany it, just say so. When we are vulnerable presenters, we sniff out insincerity or forced comments like old bones! Some of the most receptive moments are moments of absolute quiet after a presentation. Don't fill them.

- *Pay full attention.* Do give the creator the gift of your attention. Receptivity, respect, nonjudgment, and active, unspoken acceptance create the charged atmosphere through which the transpersonal can quietly permeate. In this atmosphere, each of you can hear the other speak for you in a quite uncanny way.

- *Treat yourself with the same care and respect as you treat other members.* Give your dream art the same respect, impartiality, and loving interest you give others'. This is a far cry from cold dispassion, disdain, or objectivity; it is also a far cry from overinvolvement or overidentification. This is a spiritual practice: whether alone or in a group, you have a responsibility to be your own compassionate witness.

Dreams call from the imagination to the imagination and can be answered only by the imagination.

—James Hillman, *The Dream and the Underworld*

If you are unfamiliar with dream theory, I recommend Robert Johnson's *Inner Work,* Robert Bosnak's *A Little Course in Dreams,* and Fraser Boa's interviews with Marie-Louise von Franz in *The Way of the Dream.* They are practical, imaginative introductions to dream theory founded in clinical experience and contain a welcome absence of quick fixes.

If you are familiar with and appreciate Jungian approaches to dreams, dip into the *Collected Works of C. G Jung,* Marie Louise von Franz's many works, June Singer's books including *Boundaries of the Soul,* and Marion Woodman's books. These, among other fine books, reveal with wisdom, grace, and psychological depth how dreams are worked with in Jungian analysis.

I also highly recommend Paula Reeves' *Women's Intuition,* an experienced and trustworthy guide to exploring the relationship between

dreaming and waking images, body, intuition, healing, and movement.

There are available several excellent cross-cultural reference books on symbols. Review the qualifications of the authors before you purchase them. It would be wise to refer to these books last rather than first because they can sound so authoritative that they may divert us from our unique relationship with our own material—and it is our own personal associations to our own dreams that need to carry the most weight.

Bibliography

Achte, Kalle, and Taina Schakir. "Dreams in Different Cultures." *Psychiatria-Fennica,* 1981.

Adams, Michael V. "Image, Active Imagination, and the Imaginal Level: A Quadrant Interview with Robert Bosnak," *Quadrant* XXV:2, 1992.

Aristotle. *Parva Naturalia.* (Ed. William David Ross, trans. J. Beare. Oxford: Clarendon Press, 1955.

Arrien, Angeles. *Signs of Life: The Five Universal Shapes and How to Use Them.* Sonoma, CA: Arcus Publishing Co., 1992.

Boa, Fraser. *The Way of the Dream: Conversations on Jungian Dream Interpretation with Marie-Louise von Franz.* Boston and London: Shambhala, 1994.

Bosnak, Robert. *A Little Course in Dreams.* Boston and Shaftesbury: Shambhala, 1988.

Cornell, Judith. *Mandalas: Luminous Symbols for Healing.* Wheaton, IL: Theosophical Publishing House, 1994.

Desjarlais, Robert R. "Dreams, Divination, and Yolmo Ways of Knowing," *Dreaming Journal of the Association for the Study of Dreams* 1:3, September 1991.

Downing, Jack, and Robert Marmorstein, eds. *Dreams and Nightmares: A Book of Gestalt Therapy Sessions.* New York: Harper & Row, 1973.

Edinger, Edward F. *Ego and Archetype: Individuation and the Religious Function of the Psyche.* New York: Putnam, 1972.

Ellis, Havelock. *The World of Dreams.* Boston: Houghton Mifflin, 1911.

Emunah, Renee. *Acting for Real: Drama Therapy Process, Technique, and Performance.* New York: Brunner/Mazel Publishers, 1994.

Epel, Naomi. *Writers Dreaming.* New York: Carol Southern Books, 1993.

Fagan, Joen, and Irma Lee Shepherd, eds. *Gestalt Therapy Now: Theory, Techniques, Applications.* Palo Alto, CA: Science and Behavior Books, 1970.

Gendlin, Eugene T. *Let Your Body Interpret Your Dreams.* Wilmette, IL: Chiron Publications, 1986.

Hall, Calvin S. *The Meaning of Dreams.* New York: McGraw-Hill, 1966.

Hall, Edward T. *The Hidden Dimension.* New York: Doubleday, 1966.

Handy, E. S. C. "Dreaming in Relation to Spirit Kindred and Sickness in Hawaii," in *Essays in Anthropology Presented to A. L. Kroeber in Celebration of His Sixtieth Birthday, June 11, 1936.* (Ed. Robert H. Lowie. New York: Kraus Reprint, 1969.

Hannah, Barbara. *Encounters with the Soul: Active Imagination as Developed by C.G. Jung.* Santa Monica, CA: Sigo Press, 1981.

Hillman, James. *The Dream and the Underworld.* New York: Harper & Row, Publishers, 1979.

___. "Further Notes on Images," *Spring,* 1978.

___. *Healing Fiction.* Barrytown, NY: Station Hill Press, 1983.

___. "Image Sense," *Spring,* 1979.

___. "An Inquiry into Image," *Spring* 1977.

Humbert, Elie G. "Dream Experience" in *Dreams in Analysis*. Ed. Nathan Schwartz-Salant and Murray Stein, Ed. trans. Robert Jalbert. Wilmette, IL: Chiron Publications, 1990.

Hunt, Harry T. *The Multiplicity of Dreams: Memory, Imagination and Consciousness.* New Haven, CT: Yale University Press, 1989.

Johnson, Robert A. *Inner Work: Using Dreams and Active Imagination for Personal Growth.* San Francisco: Harper & Row, 1986.

Johnstone, Keith. *Impro: Improvisation and the Theatre.* New York: Routledge, 1979, 1981.

Jung, C. G. *Collected Works of C. G. Jung.* 2nd ed. Princeton, NJ: Princeton University Press, 1970.

___. Jung, C. G. Letters. Selected and Edited by Gerhard Adler, in Collaboration with Aniela Jaffe. Vol. 1: 1906-50 trans. R. F. C. Hull. Princeton, NJ: Princeton University Press, Bollingen Series XCV, 1973, 1975.

___. Jung, C. G. Memories, Dreams, Reflections (Recorded and edited by Aniela Jaffe). New York: Vintage Books, 1965.

Kiev, Ari. *Transcultural Psychiatry,* trans. Erinnerungen, Traume, Gedanken. New York: The Free Press, 1972.

Keller, Helen. "The World I Live In," in *The World of Dreams.* Ed. Ralph Louis Woods. New York: Random House, 1947.

Laughlin, R. M. "Of Wonders Wild and New: Dreams from Zinacanta," *Smithsonian Contributions to Anthropology, Vol. 22.* Washington: Smithsonian Institution Press, 1976.

Lowie, Robert H., ed. *Essays in Anthropology Presented to A. L. Kroeber in Celebration of His Sixtieth Birthday, June 11, 1936.* New York: Kraus Reprint, 1969.

Maritain, Jacques. *Creative Intuition in Art and Poetry.* Princeton, NJ: Princeton University Press, Bollingen Series XXXV.1, 1953.

Martin, Stephen A. "Smaller Than Small, Bigger Than Big: The Role of the 'Little Dream' in Individuation," *Quadrant* XXV:2, 1992.

Matsumoto, Michihiro. *The Unspoken Way.* Tokyo and New York: Kodansha, 1988.

Mattoon, Mary Ann. *Applied Dream Analysis: A Jungian Approach.* Washington: V. H. Winston and Sons, 1978.

Miller, Alice. *Pictures of a Childhood: Sixty-Six Watercolors and an Essay.* New York: Farrar, Straus & Giroux, 1986.

Mindell, Arnold. *Dreambody: The Body's Role in Revealing the Self.* Ed. Sisa Sternback-Scott and Betty Goodman. Santa Monica, CA: Sigo Press, 1982.

Minh-ha, Trinh T. *Woman Native Other.* Bloomington and Indianapolis, IL: Indiana University Press, 1989.

O'Nell, Carl W. *Dreams, Culture, and the Individual.* San Francisco: Chandler & Sharp, Publishers, Inc., 1976.

Perera, Sylvia Brinton. "Dream Design" in *Dreams in Analysis.* Ed. Nathan Schwartz-Salant and Murray Stein. Wilmette, IL: Chiron Publications, 1990.

Perls, Fritz. "Four Lectures" in *Gestalt Therapy Now: Theory, Techniques, Applications* Ed. Joen Fagan and Irma Lee Shepherd. Palo Alto, CA: Science and Behavior Books, 1970.

Petchkovsky, L., and J. Cawte. "The Dreams of the Yolngu Aborigines of Australia." *Journal of Analytical Psychology* 31:4, 1986.

Sarris, Greg. *Keeping Slug Woman Alive: A Holistic Approach to American Indian Texts.* Berkeley, CA: University of California Press, 1993.

Schwartz-Salant, Nathan, and Murray Stein, eds. *Dreams in Analysis.* Wilmette, IL: Chiron Publications, 1990.

Shlain, Leonard. *Art & Physics: Parallel Visions in Space, Time & Light.* New York: William Morrow and Company, Inc., 1991.

Signell, Karen A. *Wisdom of the Heart: Working with Women's Dreams.* New York: Bantam Books, 1990.

Silko, Leslie Marmon. *Ceremony.* New York: Viking Press, 1977.

Singer, June. *Boundaries of the Soul: The Practice of Jung's Psychology.* New York: Anchor Books, 1972.

Stewart, Kilton. "Dream Theory in Malaya," in *Altered States of Consciousness* Ed. Charles T. Tart. Garden City, NY: Doubleday 1972.

Swentzell, Rina, and Sandra P. Edelman. "The Butterfly Effect: A Conversation with Rina Swentzell," *El Palacio* 95:1, Fall/Winter 1989.

Tart, Charles, ed. *Altered States of Consciousness.* Garden City, NY: A Doubleday Anchor Book, 1972.

Tedlock, Barbara. "The Role of Dreams and Visionary Narratives in Mayan Cultural Survival," *Ethos* 20:4, December 1992.

Van de Castle, Robert L. *Our Dreaming Mind.* New York: Ballantine Books, 1994.

Von Franz, Marie-Louise. *C. G. Jung: His Myth in Our Time.* Trans. William H. Kennedy. New York: Putnam, 1975.

Williams, Strephon Kaplan. *The Jungian-Senoi Dreamwork Manual: A Step-by-Step Introduction to Working with Dreams.* Berkeley, CA: Journey Press, 1980 [1982,1985].

Wilmer, Harry Aron. *Practical Jung: Nuts and Bolts of Jungian Psychotherapy.* Wilmette, IL: Chiron Publications, 1987.

Wolf, Fred Alan. *The Dreaming Universe: A Mind-Expanding Journey into the Realm Where Psyche and Physics Meet.* New York: Simon & Schuster, 1994.

Woodman, Marion. *Addiction to Perfection: The Still Unravished Bride.* Toronto: Inner City Books, 1982.

____. *Dreams: Language of the Soul.* Cassette Recording No. A131. Boulder, CO: Sounds True Recordings, 1991.

Zoja, Luigi. "Beyond Freud and Jung: Seven Analysts Discuss the Impact of New Ideas about Dreamwork," *Quadrant* XXV: 2, 1992.

"Let's get back to your dream. What does your dream say?"

—C. G. Jung, in Mary Ann Mattoon, *Applied Dream Analysis*

Acknowledgments

What a community of loving, generous, and astute people I have had around me during the writing of this book: Judith Armenta's professional intuition put me in touch with Conari Press; Ashi and Povi kept me quiet company; Leslie Berriman, Executive Editor at Conari Press, suggested significant and much-needed improvements to the manuscript; Martha Casselman, my agent, believed in an earlier manuscript, which indirectly led to this book; Jennifer Clements assisted with valuable research background; Conari Press made its publication a delight; Joan Heyden provided sensitive creative work and commentaries; James Fadiman, as a fellow writer, has supported my experience of writing; Jan Fisher assisted with impeccable editorial work; Helen Tait accompanied me in friendship and assisted with research; Peter Hirose,

librarian, quietly obtained the unobtainable; June Matthews' wisdom and wit provided a creative matrix for the work; Stanton and Letty Mellick modeled creative lives for me, encouraged my creativity, and provided a restful environment in which the first pages were written; Paula Reeves and her discerning and loving eye offered ways to flesh out the manuscript, and she was an inspiring companion in the spiral process of writing; Mary Jane Ryan offered me the rare opportunity to write a book about what I wanted and in the form I wanted and worked with me on the first round of editing; Jacques Rutzky's writer's eye offered valuable perspectives; Dyane Sherwood brought her discernment and wide Jungian background; Jeanne Shutes introduced me to Jung, and gave each page experienced therapist's and writer's eye; Barbara Smothers provided courageous personal art and reflections; Jeremy Tarcher believed in what I wanted to say, and his kind, steady support encouraged me to keep looking for the right publishing house for my odd work; Helen Wickes provided me with helpful references and books; Marion Woodman's work and friendship have inspired me, and she generously wrote the foreword; Chrysanthe Zantis' wise words as we walked along the river encouraged me to write from a deeper place.

I also wish to acknowledge the inspiration of those writers, theorists, and practitioners whose work has enriched and furthered mine greatly. Their wisdom and words appear and reappear in this book. I mention particularly the work of Fraser Boa, Robert Bosnak, James Hillman, Harry T. Hunt, C. G. Jung, June Matthews, Carol McRae, Arnold Mindell, Sylvia Brinton Perera, Leonard Shlain, Rina Swentzell, and Marie-Louise von Franz.

A Special Acknowledgment to the Dreamers and Artists

I am grateful to the many people who have seen me for psychotherapy over the years. They have been superb, loving, and patient teachers. Their integrity, courage, and creativity continue to inspire me.

Many of those whom I am currently privileged to see in therapy indicated that they would be happy to have me include their dreams or aspects of their inner work in this book. However, inner material changes when it is exposed, regardless of anonymity. Our work together is still evolving and, I believe, needs "a clear and sheltered place" that together we provide for it until it is complete.

Instead, I have adapted, with permission, material from workshop participants and people whose therapy work with me ended years ago. Each example amalgamates various therapeutic experiences; each is true to the spirit and experience of therapy but has been fictionalized to preserve the privacy of the dreamer. Each dream represents a wave on an ocean of deep and treasured work to which I was a privileged witness. I am grateful to these dreamers for their wisdom, trust, and generosity, and to those who currently explore with me and teach me about the creative wisdom of the heart and soul.

Index

An Australian by birth and upbringing, Dr. Jill Mellick has been in private practice for many years as a Jungian-oriented clinical psychologist and registered expressive arts therapist in Palo Alto, California. Her earlier graduate work was in English Language and Literature.

Her most recent books include *Coming Home to Myself* (with Marion Woodman) (Conari, 1998); *The Worlds of P'otsunu* (with Jeanne Shutes) (University of New Mexico Press, 1996); and *The Natural Artistry of Dreams* (Conari, 1996).

She is a multidisciplinary artist: A published poet, she also has held one-woman art shows of her landscapes, and her work is held in private collections in Canada, Australia, France, Scandinavia, and the United States; her photography is exhibited in the State of the Arts virtual gallery.

She is Full Professor, Director of the Online Extension Division, and Director of the Center for the Contemplative Arts and Studies in Creative Expression at the masters and doctoral level at the Institute of Transpersonal Psychology.

She travels and teaches internationally, focusing on the cross-cultural use of the arts for psychospiritual development. She has also spent twenty-five years visiting and living part-time in Santa Fe, New Mexico, where she has worked with the Pueblo peoples of the state as a clinician, writer, colleague, and friend.

For more information on Jill Mellick's books, work, and activities, visit her website at www.jillmellick.com

CONARI PRESS publishes books on topics ranging from spirituality, personal growth, and relationships to women's issues, parenting, and social issues. Our mission is to publish quality books that will make a difference in people's lives—how we feel about ourselves and how we relate to one another. We value integrity, compassion, and receptivity, both in the books we publish and in the way we do business.

As a member of the community, we donate our damaged books to nonprofit organizations, dedicate a portion of our proceeds from certain books to charitable causes, and continually look for new ways to use natural resources as wisely as possible.

Our readers are our most important resource, and we value your input, suggestions, and ideas about what you would like to see published. Please feel free to contact us, to request our latest book catalog, or to be added to our mailing list.

2550 Ninth Street, Suite 101
Berkeley, California 94710-2551
800-685-9595 • 510-649-7175
fax: 510-649-7190 • e-mail: conari@conari.com
www.conari.com